LIVING THE DREAM
THE MORNING AFTER MUSIC SCHOOL

A DIY GUIDE TO THE MUSIC BUSINESS

BRIAN B. HORNER

Including Foreword by Jeff Coffin, 3x Grammy-winning saxophonist and member of Dave Matthews Band and co-author of "The Articulate Jazz Musician"

Kendall Hunt
publishing company

Book Team
Chairman and Chief Executive Officer: Mark C. Falb
President and Chief Operating Officer: Chad M. Chandlee
Vice President, Higher Education: David L. Tart
Director of Publishing Partnerships: Paul B. Carty
Product/Development Supervisor: Lynne Rogers
Vice President, Operations: Timothy J. Beitzel
Project Coordinator: Sara McGovern
Permissions Editor: Caroline Kieler
Cover Designer: Suzanne Millius

Cover image © 2014 Shutterstock, Inc.

Kendall Hunt
publishing company

www.kendallhunt.com
Send all inquiries to:
4050 Westmark Drive
Dubuque, IA 52004-1840

Copyright © 2015 by Kendall Hunt Publishing Company

ISBN 978-1-4652-7782-4

All rights reserved. No part of this publication may be reproduced, stored in a retrieval system, or transmitted, in any form or by any means, electronic, mechanical, photocopying, recording, or otherwise, without the prior written permission of the copyright owner.

Printed in the United States of America

Dedicated to my parents, Dick and Nancy, and my teachers, Don Sinta, Tom Ives, and Joe Dragone, who led me to believe that I could do anything.

Contents

Foreword by Jeff Coffin **vii**

Preface **ix**

Acknowledgments **xi**

About the Author **xiii**

CHAPTER 1 **Warm Up** – *An Introduction* **1**

CHAPTER 2 **Intonation** – *Playing Well With Others* **5**

CHAPTER 3 **Rhythm** – *The Daily Grind* **9**

CHAPTER 4 **Stage Presence** – *The Face of the "Company"* **13**

CHAPTER 5 **Tone & Musicality** – *Finding Your Voice* **25**

CHAPTER 6 **Articulation** – *Attention to Detail* **39**

CHAPTER 7 **Scales** – *The Building Blocks of the Business* **47**

CHAPTER 8 **Repertoire** – *Programming the Concert of Life* **65**

Appendix **67**

Foreword from Jeff Coffin
3× Grammy-winning saxophonist and member of Dave Matthews Band
Co-author of The Articulate Jazz Musician

Having read Brian Horner's book, *Living The Dream*, and having done nearly all the things, he outlines in it at one time or another, I honestly believe this is a *must read* for every aspiring musician bent on a career in music. The degree of complication to go from the practice room to the stage to the bank is extraordinarily high, and it takes a lot of effort, know-how, and determination to succeed in music. In *Living The Dream* Brian has outlined a clear, precise, and yet negotiable way of applying this process to various musical career paths.

As performers, teachers, and composers, we have to deal with many variables that most jobs don't even consider including the possibility that people don't really want to buy or use what we have to offer. More often than not, though, that's not really the case. Many times, it's that we don't know how to get what we are selling in front of the right people. This book provides the necessary clues and pathways for how to do just that—and they are written right out in the open, not hidden in the dark recesses of someone's brain who is trying to keep all the information for themselves to get and keep all the work! This is the "new school," not the "old school."

This is a selfless book written by a selfless person. I know this because I have been working closely with Brian for many years, and I can tell you that he is the real deal! I would not have the success in certain areas of my career if it were not for his help, dedication, and professionalism. He has made my life much smoother and more manageable, and I am grateful for him.

Prioritize professionalism. This one sentence, for me, reveals what this book is all about and its primary importance. Being able to play your instrument at a very high level is a given if you want to be a working musician. Being able to utilize different teaching methods and styles is a given if you want to be an educator. The variables outside these areas of expertise and specialization are what bring people to you (and you to them) and will help determine your success. Think of it as being a stone but you need to be a magnet instead. This book helps you magnetize yourself!!

Another testament to Brian's success is the professional and personal relationships he builds with others. It's not unusual that one or more of the people who bring me in for a gig or clinic go out of their way to tell me how easy it was to work with Brian and how smoothly everything worked out. He is representing me as well as representing his business and I feel he does this at the highest level. Brian has what I call "people chops." I made the right choice when I hired him and he has helped me present what I do in a more efficient and professional way. I can attest that the methods outlined in this book work—and they work *well*!

Preface

As musicians, we hear a lot of doom and gloom comments about careers in music—everything from "nobody buys albums anymore" to jokes like "How do you get a musician off your doorstep? Pay for your pizza!" I've always found it kind of boring. Formats are changing, the industry's models are changing, but I believe we can rest easy in the knowledge that music fills a universal need. It's not going away. And our pursuit of a career that involves making music fills a need within ourselves—we *have* to try this. While times are hard for big music corporations, there has perhaps never been a time of greater possibility for indie musicians—across all genres. The world is literally at our fingertips, and our "customers" are open to new ways of experiencing and consuming our music.

That being the case, let's ignore the naysayers and find a way to make this work. That's the purpose of this book. If your music school existence is anything like mine was, you spend most of the waking hours of every day pursuing excellence on your instrument. And you pursue this to the exclusion of almost everything else. This focus is great for your playing, but may result in a lack of training and preparation for the non-musical aspects of your future career. I hope that this book will help prepare you, both technically and philosophically, for the journey that lies ahead.

Acknowledgments

There are several people I'd like to thank for their parts in teaching me the material contained in this book and in helping to bring it to fruition.

My parents and sister have always been incredibly supportive as I prepared for and embarked upon my career—that's not always the case and I'm very grateful. They were also my early editors, reading drafts and making valuable suggestions.

My wife, Erin, and my daughter, Anna Kate, are more important than anything having to do with books and careers; I'm grateful for all that they bring to my life.

My teacher, Donald Sinta, has shared his wisdom with me and many others—not only about saxophone, but about life as well—and has served as an amazing example.

Jeff Coffin may be the busiest person I know, even when he's "off." He's usually busy trying to bring the magic of music to as many students and people as possible, and I truly appreciate his taking the time to provide such a generous and thoughtful foreward.

Thank you to Scott Wilson at the University of Florida. Scott is the author of Kendall Hunt Publishing's *The Ultimate Jazz Tool Kit*, and I appreciate his encouragement and advice, and his introducing me to the company.

Paul Carty, Lynne Rogers, and the team at Kendall Hunt have been wonderful to work with, and I appreciate their creativity and enthusiasm for the project.

I appreciate my clients and the trust they put in me. I love their art and I love working with them to take it to the next level. Thanks also to my interns, Alex Clayton and Alex Mathews, for all of their help in this mission.

Thank you to D'Addario Woodwind and Conn-Selmer for making great products and for being great partners as we work together to share this information that I hope will be helpful to many.

Thanks to my students at Austin Peay State University for a dozen years of allowing me to workshop some of these ideas and philosophies.

And thank you to the following people for their valuable support and contributions to this book: Howard Levy, Don Gorder, Kristen McKeon, Erik Ronmark, Victor Wooten, Tony Pierce, Peter Strickland, Doug Rose, Mark Overton, John Mock, James Korn, Derrick Pierce, Laura Pierce, Wendy House, Meats Meier, Jimmy Thomas, Erin Thomas, Pedrosaxo, Mike Eldred, Paul Gambill, and Gretchen Peters.

About the Author

Brian Horner serves as Adjunct Professor of Saxophone at Austin Peay State University and is the owner of Sound Artist Support, a company that provides custom marketing and management to independent artists and musicians. He is featured as the music business instructor in Kendall Hunt Publishing Company's *Ultimate Online Jazz Workshops*, alongside Grammy-winning artists Gordon Goodwin, Jeff Coffin, and others, and presents music business and entrepreneurship clinics around the country. He is a graduate of the University of Michigan School of Music where he studied with renowned saxophonist and pedagogue Donald Sinta.

Horner's music business career has included stints with the Nashville Chamber Orchestra and Warner Bros. Records before the formation of his own company, Sound Artist Support, in 2008. SAS provides custom artist development and management to a diverse roster of world-class artists.

As a saxophonist, Horner has premiered more than 10 new works for saxophone. He has appeared at such venues as Carnegie Hall's Weill Recital Hall, Steinway Hall and New York City's Mannes College of Music, as well as at the Glimmerglass Opera's Young Artist recital series in Cooperstown, New York. Joined by pianist Elizabeth Avery, he released *Saxophone Music of M. Zachary Johnson—Live At Steinway Hall*, and *Serenade—Music for Saxophone & Piano*. In reviewing the CDs, *Saxophone Journal* praises Mr. Horner's "warm, vibrant sound" and hails the music as "a very valuable addition to the saxophone's repertoire" and "pure joy for the ears." The *Live* album rose to become a "Top Seller" at CD Baby, and Horner was subsequently featured on the cover of *Saxophone Journal*. He can also be heard in a featured role on Nashville Songwriters Hall of Famer Gretchen Peters' recording of "The Aviator's Song."

Brian Horner is a D'Addario Woodwinds Performing Artist endorsing Grand Concert Select reeds and a Conn-Selmer Artist endorsing Selmer (Paris) saxophones. He lives in Nashville with his wife and daughter, and their dog.

www.brianhornermusic.com
www.soundartistsupport.com

CHAPTER ONE

Warm Up
An Introduction

When I arrived at the University of Michigan School of Music as a freshman saxophone performance major, I had a lot in common with my peers. I was full of dreams, ambition, confidence, and raw talent. And, like many of my peers, I quickly learned how raw my talent truly was. My dreams weren't unrealistic, but it was going to take all of my ambition and drive and capacity for hard work in order to refine my skills enough to achieve my goals.

The next 4 years were spent in the practice room, learning how to practice, how to play in tune, refining my technique, developing a personal tone and musical style, and raising my standards with regard to rhythmic precision, articulation, and all other areas of musical performance. I was swept into my instrument's mainstream career trajectory—which for classical saxophone includes multiple degrees and classical academia—and proudly pursued my future with a laser-like focus. During my senior year, however, I realized that I'd drifted off course. My quest to build a solid foundation in order to support my initial dreams of studio and touring work and playing saxophone in a variety of settings and genres had become an entirely different thing—one that wasn't in keeping with my true artistic compass. This was the time to re-evaluate my plans. Reconnecting with my original musical passions and integrating my skills and interest in the business side of music, I changed course.

I moved to Nashville after graduation, got a job as an administrator (and later as a player) with a genre-defying chamber orchestra, and began an uncharted, 10-year exploration of various facets of the music business—from classical administration to major-label work that included work on releases by Larry the Cable Guy, Blake Shelton and others, and from performances with the Nashville Symphony and as a solo recitalist at Carnegie Hall to a performance of "Yakety Sax" with all of Nashville's saxophone players at a memorial service for Boots Randolph. At the end of a 4-year stint at a major record label I found myself deeply unhappy with the corporate culture and burned out from the effort of maintaining

my teaching and playing career after-hours (teaching college saxophone lessons and practicing in the evenings at the same time that I had a young family).

I had spent time in full-time administrative "day jobs," and I'd spent time as a self-employed musician and private lesson teacher. One offered a steady paycheck with little freedom to pursue my life as an artist and the other offered unlimited freedom but came with little in the way of reliable compensation. I badly wanted to find a balance—but such a job didn't seem to exist.

My years in Nashville had exposed me to a diverse group of musicians working in a variety of genres. I decided to have a series of conversations with some of these people to talk about the business, "shake the tree" and see what ideas might fall out. I set no rules and no parameters and had no expectations for where these conversations might lead. I was at a loss. I saw no clear path ahead.

After a few of these meetings, all of which were positive and helpful, I had the "aha!" moment that I had been seeking. Grammy-nominated singer-songwriter Gretchen Peters, whom I had gotten to know through her performances with the Nashville Chamber Orchestra and whose recording of "The Aviator's Song" featured my soprano saxophone work, arrived at our meeting a few minutes late and a bit scattered from a day spent running a variety of disparate errands. "I don't need a full-time person, but I need a part-time person who knows how to do a lot of different things—someone who can be a publicist, a manager, an assistant," she explained as we settled in with our coffee. I had a moment of clarity, and realized that I could be that person. She became my first client.

I harnessed the diversity of my accumulated experience and started a company that is still providing jack-of-all-trades business support to artists across all genres. My roster has included pioneering classical artists and composers, ACM and CMA award-winning songwriters, and Grammy-winning jazz and rock stars. I'm a manager, a booking agent, a marketing consultant, an assistant, a publicist, a radio promoter, an educator, an amateur psychologist . . . and still a saxophone player and college professor. I have the freedom to pursue the musical projects that I choose and I have the amazing opportunity to work with some of the world's most creative and inspiring musicians—some of whom I have been listening to since high school. Even without a saxophone in my hands I have a very definite sense of being part of the music-making when I help to set up a tour or when I imagine a new way for a musician to deliver his or her art to an audience. In doing this work I'm not only living my own dream but am also helping others to live theirs.

My skill set has been refined and expanded almost entirely through on-the-job training. I've learned (and am still learning) the skills that I need to turn my passion for making music into a career that can support

myself and my family. I didn't have time to learn those skills in college (though my training did begin while working at music camps during my college years). I couldn't have become a good enough player if I had had the diversion of required business and career courses, and so a situation existed where the development of the two separate skill sets seemed mutually exclusive. This is a common dilemma for music majors and music schools across the country, and in this book I offer practical business skills and creative approaches to building and supporting a life that allows you to pursue and live your dream. The chapters that follow focus partly on technical advice and skills, and partly on philosophical concepts that I hope will be helpful along the way.

I will use familiar, fundamental skills from the study of music as a framework for introducing the corresponding skills on "the business side." A glance at the table of contents illustrates this method:

1. Warm Up—*An Introduction*
2. Intonation—*Playing Well With Others*
3. Rhythm—*The Daily Grind*
4. Stage Presence—*The Face of the "Company"*
5. Tone & Musicality—*Finding Your Voice*
6. Articulation—*Attention to Detail*
7. Scales—*The Building Blocks of the Business*
8. Repertoire—*Programming the Concert of Life*

I offer the story of my career as an example of a creative, individual, highly customized solution. It is, as my friend and client Jeff Coffin would say, a "creative way of being creative." It is not intended as a literal suggestion—I don't want competition! Each of you will have your own priorities, whether artistic, financial, or entrepreneurial, and you'll have to find a balance that is right for you. My goal is simply to point out that there may be many more paths available to you than the few that seem apparent at first glance, and to give you some tools with which to create your own path. I believe that we are, by nature, creative people and that it is our creativity that compelled us to begin this journey in the first place. Some musical settings cultivate creativity more than others but, no matter what type of musical work you do, it is critically important to hold on to that quality and to apply it not only while you're making music but also in the global pursuit of your career. *Webster's Ninth New Collegiate Dictionary* defines the word "creative" as "having the quality of something created rather than imitated." This means that the path in front of you does not need to be well-worn—indeed, there doesn't need to be a path at all.

CHAPTER TWO

Intonation
Playing Well With Others

The pursuit and development of intonation as a musician is a two-pronged endeavor. As you know, you must possess or develop the ability to hear pitch discrepancies and then be able to adjust your instrument's pitch accordingly. Listening to others and adjusting. If you're unable to develop these skills to a very high level, then you simply will not be able to become a professional musician. The same is true of personal interactions. Problematic personality characteristics—arrogance, aggression, various manifestations of insecurity—can and will affect your ability to get and keep work. There are enough aspiring professional players that technical and musical prowess are a given. You'll find that intangibles such as personality and reliability are some of the things that thin the pack.

It's easy for young, flashy players to be dismissive of older ones who may seem to have rust starting to appear on some areas of their playing. This is especially true when you've just graduated from college and have been in a period of your life when practicing your instrument for hours every day was the only valid way to spend time. But there are a couple of things that are important to note about your new colleagues. First, their years of professional experience have taught them things and given them skills that can only be gained by . . . well, years of professional experience. These aren't things that you can measure with a metronome or polish in a practice room. Secondly, these are often people who balance their career in music with the other parts of their lives. "Other parts of life" may not be things you've had to deal with to this point. They balance paying bills, owning a home, being a husband or wife, and raising children. As you get older you'll realize that your career, like life, is a marathon rather than a sprint. There's more to it than speed of technique and precision of rhythm. Though those things are important, they are not central—it's the expression of emotion that is central. And the mastery of *that* skill, the ability to exist on *that* musical plane, comes from the other parts of life.

It's okay to have swagger and there's real value in confidence. But embrace the concept that there are lessons to be learned and gained from

everyone you meet in "the scene." No matter how good you are or how big a fish you were in whatever pond you were swimming in, you're a rookie at the professional level. Enjoy it. Look and listen for the things that your new colleagues can teach you. This humility will not only benefit you musically but will also set you on a path toward creating genuine relationships that will form the foundation of your career. After all the hours in the practice room, it's strange to think that relationships, rather than the speed of your scales, will form the foundation of your career. But it's true.

Though it's essential to be a lifelong learner, part of transitioning into being a professional is recognizing and having confidence in what you bring to the table. In the context of habitually listening to others, view yourself as a colleague—you're out of school now and trying to work alongside these people. This is a complicated concept. I realize that it sounds like I'm now recommending an approach that is the opposite of what I described in the last paragraph. It's subtle and could be thought of as a simple mental adjustment. Mentally award yourself a promotion. Yes, there is plenty you can learn from those around you—that's always true for all of us—but you're here doing this job because you've finished your formal training and someone believes that you're qualified for the job (whether it's a church gig, an orchestra gig, or a recording session). So while you can learn from others, perhaps they can learn from you, too—they need to be listening, too. You're now on a two-way street.

To continue with the two-way street metaphor, it's a crowded street that sometimes has more cars than parking spaces. Competition is inevitable. I've always felt that the most efficient way to approach competition is to focus solely on executing and elevating your own personal best. To look from side to side and to worry about where others are in the race only serves to waste energy. If you truly do your best—and strive to make your best better—you will achieve all that you're capable of achieving. You may win or lose the race by a mile or by a hair. But if the drive and motivation comes from within, I believe you'll end up going further. However, this approach is not only about whether you win or lose—it's also about how you play the game. By focusing on your own game rather than that of everyone around you, you avoid the temptation to throw your elbows and jockey for position. You avoid the paranoia or gloating that might rise to the surface otherwise. You don't appear as a threat to your competitors, triggering their own fears and anxieties. By playing your own game and avoiding these pitfalls you make yourself a better, more likeable colleague and that can make all the difference.

Lastly, there's the obvious—don't be a jerk. I don't think that needs a lot of explanation. What kinds of players and people do you like to hang out with and work with? Be like that!

Being a professional musician is a very social way to make a living. It can also be very high-pressured which makes "the hang" all the more

important. Assuming you've got your musical stuff together, being pleasant and easy to be around will be a great asset.

Top ten behaviors to *avoid* when trying to get and keep work as a musician:

10. Brag about your college accomplishments to anyone and everyone you meet.
9. Spread news of your successes and busy-ness without regard for the struggles of others.
8. Use warm-up time to run through [insert your instrument's repertoire's most difficult passage here].
7. Consistently take the position that you are right (and that somebody else must've made the mistake).
6. Waste your colleagues' time by showing up late or missing rehearsals or gigs.
5. Waste your colleagues' time by showing up unprepared for rehearsals or gigs.
4. Fail to return calls or emails.
3. Be high maintenance.
2. Jockey for position by speaking negatively of others.
1. Pin a producer against the wall of a studio because he hasn't continued to hire your wife (sadly, a real-life example!).

CHAPTER THREE

Rhythm
The Daily Grind

Every song or piece of music has a rhythm or pulse that keeps moving throughout. It may speed up or slow down or it may stop and start, but it propels the piece from beginning to end and it does not wait. It doesn't wait for you to go back and correct a mistake and it doesn't wait for you to catch your breath. It moves along. And so it is with careers and business and life.

Think of the schedule you kept in college as being a piece of music in 4/4 at a moderate tempo. I regret to inform you that your "real life" schedule will be more like an avant garde piece with mixed meters and changing tempos that includes some odd time signatures like 7/16 and 11/8.

One of the most important lessons I learned from my saxophone professor, Don Sinta, was that "you have to be your own best teacher." During college you met with your lesson teacher—by far the most important teacher in your collegiate life—for about an hour every week. The rest of the time you were on your own to apply your teacher's teachings. Not only did you have to practice, you had to learn how to practice, how to look and listen inward and critique yourself, and how to challenge yourself and apply the kind of pressure and guidance provided by your teacher during your lessons. This only gets more important after graduation. There are many more demands on your time, with paying the bills being the newest, biggest, and most stressful of these. And there is far less, if any, structure. You still have to practice, but now you also have to invest time in the development of your career. This may mean keeping track of and preparing for orchestra auditions across the country or world, developing a professional network that will feed a freelance career in your new city of residence, preparing materials that promote yourself and your skills, or any number of other tasks.

Another thought that motivated me in college was the notion that during any hour that I wasn't practicing there was someone, somewhere, that was. And that person wanted the same things that I did. The same is true after school when everyone is working to put together the pieces of a

career. There is a constant need to remain focused and to keep an eye on the trajectory of your career, beyond just your conditioning and progress as a player. It's important to network in an ongoing way, develop a constant presence in your field, and stay in the consciousness of your field's decision makers. Intermittent flurries of activity and communication will not provide the type of long-term promotion that is necessary. It is also vitally important to realize the importance of taking an active approach to promoting yourself, rather than a passive one. In college many things are merit-based. Chair auditions for orchestra and band are based primarily on who delivers the best performance. You're graded based on the quality of work you deliver on your assignments. You're given opportunities and rewarded (or not) based on what you make of them. After college, you need to create opportunities. Most often they will not fall into your lap. One of the most important services that I deliver for my clients is constant attention paid to the task of creating opportunity. Where it doesn't exist I create it—and then pursue it relentlessly. If you are not working actively on the development of your career nothing will happen and months or years will pass. Get on it! But how?

In keeping with the structure I've established here of drawing parallels between musical skills and business skills, consider the way in which you shaped your practice routine in college or the way you approached a new piece of music.

In your practice routine there was probably some sort of a warm-up period that included fundamental exercises—scales, long tones or overtones, intonation exercises, tonguing exercises, thirds, and so on. Then maybe you moved into etudes, small pieces of music designed to present specific challenges that you'd face in the repertoire. Then maybe ensemble music and solo literature. You divided your time into distinct study areas, probably moving from the general (or fundamental) to the more specialized. As you approached a new piece of music, you probably took the time to get a sense of the piece as a whole. Perhaps you listened to recordings, studied the score, and analyzed the structure. You could probably hear in your head what it would sound like on stage and maybe what it would feel like under your fingers. This was all a precursor to the hours of technical practice, the working out of fingering patterns and articulations and the repetition of particular passages.

Take the time to apply this same sort of thoughtful approach to the business tasks that lay before you. Begin with a quiet assessment of the situation ("situation" being used here as an understated term for your career, life, and entire future!). Where are you headed? Now that you've built a solid foundation and spent thousands of hours becoming a great musician, what is the next step? And the step after that? You don't need to have specific answers to these questions, as the answers will evolve over time. But you need to be thinking consciously about them. What would you like

your life and career to look like in a year, 2 years, or 5 years? Write a bit about your vision, something you can check in with over time. Make a list of your goals in outline form—main goals with "sub-goals" underneath. This can be as formal or as informal as you'd like, but it will serve as a sort of roadmap for your journey.

For the purpose of this discussion of time management and the daily work of pursuing your long-term career goals, I will assume that in the months and years immediately following college you will have a "day job." This is the job that musicians (and any artists) sometimes need in order to support their artistic quest. It might be waiting tables or delivering pizzas, or it might be a job more closely related to your training such as teaching private lessons or working in an orchestra's administration. Whatever it might be, it is likely to take up the majority of your waking hours. Practicing and maintaining yourself as a player will take up much of your remaining time. You can see that it would be easy for the long-term career-building work to fall through the cracks. But it is critical that that not happen. For this reason I suggest identifying blocks of time for exactly this purpose. Whether it is time set aside daily or twice a week—whatever makes sense within the context of your schedule and your goals—you need to view this time as the important appointment that it is. Do not allow anything to interfere with it.

Once you have a sense of where you are going, you can begin to plan the route you will take to get there. This list of steps will be fairly customized according to your career goals, your skill set, and even the city where you live. But the tasks will probably fall into several main categories:

Marketing
As discussed above, you've now given some thought to who you are as an artist and musician and where you'd like to go. You now need to generate the materials that you will use to communicate this vision. You'll need to write a bio that not only discusses your past accomplishments but also gives a sense of who you are and what sets you apart from others. You may need to create a brochure that summarizes a service you offer such as private lesson instruction, wedding music performances, or recording overdubs. You'll need a few good publicity photos of yourself that communicate who you are today. And you'll use all of this content to populate your online profile—your website and social media sites (Facebook, Twitter, etc.). These are just several examples of the types of marketing materials you'll need to generate.

Publicity
How will you get people to see your materials and to learn about you and your "business?" A great-looking website is important, but only if people see it. Consider things like search engine optimization (SEO) and online ads (such as pay-per-click ads on Google and Facebook). Perhaps

you need to send emails to local band directors or drop off flyers at the school. Use a local music store's posting board to let people know that you're looking for a band or are available for recording sessions. The right answers and strategies will depend on your own personal context, but this gives you an idea of the sorts of things you should be considering.

Research
Your research will be focused on learning about the inner workings of the organizations or communities that you would like to join. Where are there orchestral openings for your instrument? When are the auditions? What will it cost to get there? What are the best band programs in the area and do they employ private lesson teachers? Who contracts recording sessions in your city and who are some of the key players? Whatever your interests and goals may be, research carefully and extensively in order to learn who/where/what/when/how.

Networking
Networking just means making new friends in your prospective area of work. And, done well, it is not just superficial self-promotion (though that is the connotation that often springs to mind). People have to know that you exist, that you live nearby, that you are available, and, most importantly, that you are pleasant to have around. Lead with questions rather than boasts. "I'm new in town. Can I buy you a drink? I'd love to hear more about the scene." This is a far better approach than "I just graduated from Juilliard and am really going to be able to help you guys—can I get the contractor's number from you?" Realize that no matter how much you may have to offer, the people who are already doing the work you'd like to be doing have a lot to offer you as well.

The purpose of this chapter has been to give some shape and organization to the heaping pile of "other stuff" that you know you need to be addressing, and to make it less overwhelming. I'll discuss these tasks in greater detail later on.

CHAPTER FOUR

Stage Presence
The Face of the "Company"

It's go time. Perhaps, today is your end-of-semester jury or it's finally the day of your senior recital. You've been working and sweating in the practice room for weeks, learning the notes, practicing scales, working on your intonation and tone, and eventually doing the precise fine-tuning of your piece. All of this so that you can go into the jury room or the recital hall and demonstrate what you've learned, hopefully impressing the faculty and your peers along the way. Through this whole process you've probably given little thought to your appearance and how you present yourself in the practice room—and that's fine. But today is different. In addition to being evaluated on your musicianship and technical execution, the faculty will make notes in the column that reads "Stage Presence."

You've made plans to arrive early and, ideally, you will have planned your attire for the performance and given some thought to your personal appearance and grooming. Maybe a suit and tie, maybe an evening gown, maybe just a professional-looking "business casual" outfit. Any of that is fine, as long as you've given it some thought and are presenting yourself cleanly and professionally. You're dressing for the concert hall, not the band room/choir room/classroom or wherever your jury may be held. And take it a step further—visualize your entrance into the room, your shoulders back, smiling, and with a gait that isn't fast or slow but that conveys confidence rather than exposing your inevitable nervousness. You're demonstrating how seriously you're taking the occasion.

Fast forward a few years. Now it's time to apply for a job, whether a formal "job-job" or a "gig" (the musician's version of a job). The same principles that applied on jury day should apply here. You're still dressing to make a strong, professional appearance, but much of it will be done remotely. Initially you'll be evaluated on the strength of your "materials." These may include your introductory emails, phone calls or letters, your

resume, your website, an audio or video recording, a photo or headshot, or accumulated testimonials or press quotes—any of the various items that might make up your "press kit" or "promo package." You need to bring the same high standards and care to the task of building these materials that you bring to the preparation of your music and your physical appearance at a performance.

I evaluate a lot of promo packages. Some are from interns who hope to work for my company and others are from artists who want me to represent them. And in other situations I may be evaluating an artist who has been suggested as an opening act for one of my artists, or whom I am considering approaching about representation. In all of these cases the promo materials are going to be the first step (and sometimes the last) in answering the question "Can they get the job done?" or "Do I want to work with this person?"

The Introduction—Your First Email, Phone Call, or Letter

"You don't get a second chance to make a first impression"

In this era of abundant and instant electronic written communications, formality is almost non-existent. That's fine for almost everything—socializing, communicating with coworkers, and professional contacts with whom you already have a relationship. But for an initial communication in a situation where you're asking to be considered for something, formality and professionalism are still important—and rare. In an industry that is outrageously competitive, this is an area where it is relatively easy to stand out and set yourself apart from the crowd. Pay attention to your written word. This may sound ridiculously obvious, but take the time to double check that you've used the correct spelling for the name of the person that you're addressing and for their organization or company. If you're referring to any of their work—albums, songs, projects—take the time to make sure you've gotten it right. Read your email (or letter, etc.) aloud—this will help you catch errors and evaluate your overall tone in a different way. If time allows, put it down after writing it and read aloud again after some time has passed. In your opening sentence, state your objective clearly and follow that with a statement describing how you can meet their needs. This statement can include a bit of background but should not read like a full bio. Save this for the next paragraph. Avoid being too familiar. Presumably, this email is not aimed at a friend—do not address the recipient as such. And keep it brief, with the most important items stated first and the least important stated last. Close by thanking the recipient for their time and consideration, and include a formal closing (i.e., "Sincerely," "Best," etc.).

The Overview—Your Resume

For the aspiring musician, the resume can be a bit different than the resumes you might find online in standard templates. As a musician and as someone who has worked in the music business my whole adult life (a business which is generally less concerned with formality), I'm not in a position to give a lesson on preparing the perfect resume. But as someone who has reviewed quite a few of them, I do have some thoughts on the matter. When someone is applying for an internship with me, I want their resume to give me a feel for the seriousness with which they present themselves, their attention to detail, and the passion or drive that distinguishes them from the other applicants.

I know that there is a certain format that you're taught to follow, but I'm just not moved by a cookie-cutter resume that contains all of the same items as your classmates. Obviously, some things are going to be common—your education, your degree, and so on. But take the opportunity in, say, your "Objective" section, to actually tell me something. You want an internship in the music business—why? You want to become the violin instructor for a music store—why? What will *you* bring to the job? Dig deep and think about the experiences you've had. You may have done things that didn't seem, at the time, to be relevant "Experience" but that may actually be quite valuable in describing who you are. While maintaining accuracy and honesty, state things in the "biggest" way possible. If you taught violin lessons to a few children in your neighborhood during high school, tell me about the "Private Teaching Studio" that you "Owned and Operated" and the level of success that was attained by your students. If playing in a rock band and playing shows in your home county and the surrounding counties inspired you to want to book and promote other bands, tell me about your "Management and Booking" of "Regional Tours" for "Whatever-your-band's-name-was." Dress it up. Be accurate, but be dressy. Just like jury day.

The Online Home—Your Website

A professional-looking website is a must-have for an aspiring musician of any kind. To be clear, I do not think that you need to spend a lot of money on this. There are a number of inexpensive websites that offer template-based, DIY website design—two that I've used are Bandzoogle and Squarespace. It is easy and cheap to have a site that allows you to display photos, bio, resume, audio samples, videos, and anything else that might highlight what you have to offer. The most important aspect of your website should be the professionalism of its overall look. Because it is so easy to make a professional-looking site, it's especially unimpressive

when sites appear to be made by amateurs. You've seen the sites of your favorite companies, artists, sports teams, etc., and you know how a site should look. A simple site is fine, even if it is only a homepage. If it represents you well and delivers the information you're trying to deliver then it has done its job, and you've done yours.

10 Characteristics of an Amateur-Looking Site (Avoid These!)

1. Bad photography—don't use candid snapshots! (I'll address this in greater depth later)
2. Too many buttons in the main navigation—you probably don't need more than 5 or 6
3. Outdated or low-resolution graphics that appear "pixel-y"
4. Broken links—if you have a button leading to something, make sure it leads to that thing!
5. Poorly written text—take care in your writing
6. Unfortunate fonts and colors—you know, make it look good!
7. Use of first person in the main nav buttons (i.e. "About Me", "Contact Me", "My Music")—this may be a matter of taste but it doesn't say "take me seriously" to me.
8. Personal photos—this isn't the place for friends and family
9. Excessive numbers of PR photos—2 or 3 different poses is plenty
10. Bad photography—this is worth including twice!

The "Demo"—Your Recordings

This is an important one. It is, after all, one of two main ways (the second being a video) to demonstrate ("demo") the central product that you are trying to sell—your playing and musicianship. It can be a daunting task to put together a good demo. Focus on your playing, first and foremost. Don't get distracted by this new goal of making a recording. Once the playing is in place and you've performed the music, whether for your friends or for an actual concert audience, you're ready to plan the recording.

It's worth recording your live performances because you may get lucky and be able to use all or part of one of the pieces of music. Remember, in a demo situation you're trying to display quality, not quantity. A live recording may end up being very useful as a demo if you happen to have one minute of a performance that is particularly moving and impactful. It's also possible and affordable to make a studio recording. I use the term "studio" only to imply that it is not a recording of a live performance. You can record in a classroom, a recital hall, even a practice room if it sounds good enough. It just has to be quiet enough around you that background voices and noises do not leak into the recording.

Gone are the days that you have to pay for studio time and a recording engineer to help you record your demo. The quality of portable digital

recorders has improved dramatically (and continues to) while the cost has decreased. ZOOM makes several models that vary in price and features and that all capture exceptionally high quality audio. They interface easily with your other computers and devices for archival, editing, and broadcasting purposes. Invest $100–300 in a quality recorder and take the time to learn how to use it correctly, just as you have done with your instrument. Be careful not to buy one of the many voice recorders on the market—make sure you're buying something designed to record music. This is exactly the type of task that would be easy to ignore given the many demands on your time. But equipping yourself with the gear and skills to make a representative recording of yourself will pay great dividends. In addition to being a great way to show others what you can do, it is probably the most important teaching tool you have as well, as it allows you to hear yourself as others do.

YouTube—Your Videos

Videos are a medium where there is a lot more variety in terms of the level of professionalism. Obviously you want any video in which you appear to represent you well—don't say or do anything that you don't want being visited and revisited by others. But sometimes casual videos can be quite effective in conveying the authenticity of your art or your teaching. If the audience is watching you sit in a classroom and perform a difficult piece in front of your iPhone, it is clear to them that you haven't edited the performance and that you can truly execute what they're seeing. And from your casual commentary or dialogue "with" them they can start to get a sense of your personality.

Live performances on video are also an important part of your press kit. Again, they show an authentic depiction of what you can do. And, of equal importance, they let you see yourself as others see you. You may notice that you slouch as you stand during rests, or that you look terrified as you walk onto the stage. That video is not a loss—it's just a lesson rather than a new YouTube offering!

Again, I don't think that it's necessary to spend a lot of money on professional videography (unless you're making a product for sale—that's a different matter). ZOOM, which I mentioned before as an audio recorder, also makes a good video recorder, and GoPro is another affordable and very portable camera. Take a lot of footage and use only those moments that capture the magic of what you do.

The Image—Your Photography

As previously stated (twice!), poor photography is a pet peeve of mine. I see a lot of it. And I see a lot of great photography. When I refer to "poor

photography," I'm referring either to casual snapshots that people decide to use as PR photos in a professional setting, or actual professional photos that are of poor quality or poorly conceived. Avoid cliché setups—this is particularly common in photos of classical musicians. I'm a classical saxophonist and the typical shot for classical saxophonists seems to be a pose with the artist in a tuxedo holding the saxophone in an awkward and unnatural position that bears no relation to its playing or resting position. I'm sure there are equivalents for other instruments. Another that appears often is the shot in which the player is holding up the instrument with a big smile, as if to say "I love my flute!" Doesn't work for me!

 Be creative with your photography. Again, it doesn't have to be expensive. You may have a friend with a great camera who would be excited to help you get some good shots. With Photoshop or iPhoto it's relatively easy to fix lighting, correct red-eye and blemishes, and do the minor editing that might be required. But spend some time thinking about who you are as an artist and what you want to convey. What is your music like? What is your concert like? What do you wear when you perform, or what do you plan to wear now that you're launching your professional career? Think about the concept of continuity. Do you look in your photos like you sound in your music? I think that's important. There are lots of people applying and auditioning for positions, and this is one of several ways that you can distinguish yourself. Although there are types of photos that are customary, don't view these customs as hard and fast rules. Stretch out a bit—think freely and try to capture the essence of you and what it is that you do. Remember, you'll need to take tens of photos to get a couple that are really great—that capture a great expression that really tells your story. I remember being really pleased with a photo shoot I did that yielded a handful of great shots out of about 90 that were taken. So shoot away—and while you're at it, maybe grab some of those typical, traditional shots just in case!

Chapter Four: Stage Presence - *The Face of the "Company"* 19

Here are a few examples of ones that I like.

Multi-instrumentalist, composer, and photographer John Mock

John Mock

Saxophonist Brian Horner

D. Pierce Studio

20 Chapter Four: Stage Presence - *The Face of the "Company"*

Pedrosaxo—a shot that truly captures the unique vision of this artist

D. Pierce Studio

Chapter Four: Stage Presence - *The Face of the "Company"* **21**

Pedrosaxo—here's another (the shot is not staged or created—he actually jumped that high!)

22 Chapter Four: Stage Presence - *The Face of the "Company"*

The Quote—Your Testimonials

I find testimonials, or quotes, to be one of the most compelling components of an artists' presentation. It's great for you to be able to express through your bio and website what a wonderful player, person, and teacher you are, but it's even better when someone else says it. Many people who have interacted with you may be willing to offer a quote that you can use. Think about studio teachers, conductors, other professors, parents of private students, or teachers from your student teaching experiences—people with whom you had a positive, meaningful experience. Ask them politely if they would mind sending you a quote that you can use for promotional purposes. I often give people a chance to decline gracefully by saying that I'll understand if this is not something "they do." This gives them the option of saying "no" without the situation being awkward, and it also ensures that the quotes you receive are sincere and compelling.

You can use these to assemble a separate quote sheet, or you can include 2–3 of the best quotes at the bottom of your bio or on the homepage or "About" page of your website. I almost always use quotes when pitching an artist for something, and I think that they look great if either the quote or the person giving the quote is in italics—it causes it to stand out on the page nicely. Though it may seem trivial, these are the sorts of details that I think are important to consider.

Sample (but Real) Testimonials from My Press Kit (both Music and Business)

"Brian is easy to work with and the feedback I have had from others he has worked with on my behalf has been one hundred percent positive and glowing."

Jeff Coffin—3× Grammy-winning saxophonist/composer/educator
Dave Matthews Band, Bela Fleck & the Flecktones,
Jeff Coffin & the Mu'tet

"Sound Artist Support is the perfect partner—top artists with top-level support."

Paul Gambill—Executive Director, Community Engagement Lab

"Sound Artist Support has what the independent artist needs—that is to say, a little bit of everything. It's like having a manager, personal assistant and publicist on call."

Gretchen Peters—CMA Award-winning,
Grammy-nominated singer-songwriter

"I have been working with Brian Horner since 2008, and the leap forward in my career goals has been remarkable. Brian has that special gift of being able to really get things done, make the calls, etc., yet never come off as pushy to anybody. This is a quality that is both rare and invaluable. I can always rest assured that I'm being represented in the best light by a very fine manager and person."

John Mock—nationally acclaimed composer,
recording artist, and photographer

". . . intense songs of the heart capturing the very essence of music's humanity and striving passion . . . pure joy for the ears . . ."

Saxophone Journal
March/April 2009

". . . something that will be grandly enjoyed by listeners looking for some music with depth that isn't impenetrable."

Midwest Record
Volume 32/Number 79
January 18, 2009

"The wide-range, yet warm and vibrant, tone of Horner demonstrates what a fine sound the saxophone can produce in classical chamber music."

Audiophile Audition

"Horner's newest album is honest, heartfelt, sincere and touching. Simple and beautiful."

Donald Sinta
Earl V. Moore Professor of Saxophone
The University of Michigan

See? You want to hire me and listen to my albums, right?

The Profile—Your Social Networking Sites

By now, some themes have emerged about how to present yourself in the best light. These themes will guide your social network profiles as well. Prioritize professionalism. Use a quality photograph as your main profile image—one that has continuity and *looks* like you *sound*. Whether you use first or third person, make sure that the writing (the "copy") is well-written and broadcasts an accurate and positive portrayal of you and your product. Try to separate your personal profiles from your business profiles by being conscious of the content that you post on each. It can be

hard to entice your circle of Facebook friends (on your profile) to become fans (on your page) but there are ways. Think about offering exclusive free content (a download or video, etc.) in exchange for a like.

As with the other parts of your public presentation, try to look at your profiles through the eyes of someone who is going to decide whether to hire you for a concert or to teach their child lessons, buy your music, or ask you to join their band. Evaluate whether or not your profile will be appealing to your target audience.

The task of maintaining multiple profiles and staying on the cutting edge of the social networking world can be overwhelming for the indie artist. I would recommend that you join and maintain the sites that are relevant to what you do. For example, you, as a classical pianist, can probably afford to skip a certain network if it is populated mostly by pre-teens. Once again, consider your target audience and market yourself to them.

Personally, I do not have a "the more, the merrier" approach to social networking. I think that it is adequate to be actively and genuinely engaged on a couple of sites that you have decided are relevant to your demographic. This may even give a more authentic picture of who you are and facilitate a more meaningful relationship between you and your audience than if you were on every site in existence.

That said, it is important to have some presence in this world. A web search is one of the first things I do to check an artist's credibility. If there is no online presence—limited or no search results—then I'm likely to write that artist off as having no credible activity. However, if the search results include a website and a couple of the usual social networking suspects, then it shows me that there is effort and activity and that it could be worth the time to dig deeper to find out more about this artist.

CHAPTER FIVE

Tone & Musicality
Finding Your Voice

Great musicians—whether opera singers or jazz saxophonists—have a sound that is all their own. And they are able to apply it in a variety of settings—they can make music that is eloquent, angry, contemplative, joyful, melancholy, exciting, or atmospheric. They have found their voice through the process of developing their tone and sense of musicality, and are able to communicate from a place of true authenticity. In a global sense, this is one of the many items on your "to-do" list as a serious music student. It's a concept that will be equally important to explore as you conduct your post-grad business dealings. You'll need to find a way to make an impression and stand apart from the tens or hundreds of competitors that are pursuing the same opportunities. An important part of this process will be to develop a written and spoken style that represents who you are and what you're about, and to express yourself with confidence.

"Business dealings" could refer to any number of types of emails, phone calls, cover letters, or even text messages. I've found that the most common include the following:

- Booking inquiries—approaching venues or presenters and asking them to hire you for a performance
- Inquiries directed at booking agents, managers, labels, and so on—approaching companies that may be able to help take your career to the next level
- Networking emails to other musicians—approaching musicians whom you may or may not know, but with whom you hope to work
- Special project pitches—proposing a creative idea or collaboration to a company, venue, or musician
- Logistical emails between colleagues—planning rehearsals, distributing gig details, and so on
- Audition cover letters—letters that accompany and introduce your resume and application

- Letters of interest—introducing yourself and asking to be considered for a job, position, and so on
- Publicity emails—emails to members of the media and associated publicity materials (press releases, media alerts, bios)

The nature of business dealings can tend to suppress our personalities as we strive to be proper and formal. This is natural since we may not know the person whom we're addressing and they may not even be expecting to hear from us. And this relative formality is not entirely a bad thing—professional correspondence is generally not the place for LOLs and OMGs. But it's still important that the person on the other end of your communications get a real feel for who you are and, more importantly, remember who you are. I'd like to think that I'm letting a bit of my personality come through in the writing of this book. It's professional yet also lighthearted—sort of "business-casual."

Let's look at the process of tone development (finding your voice) as it applies to your instrument. There are two main components to this process—the technical work of mastering the tone-producing mechanics of your instrument and the act of listening to other great players (of your instrument or others). In spoken and written communication, the "tone-producing mechanics" are grammar, vocabulary, and spelling, and listening is . . . listening. My writing and speaking are largely products of listening to others and having a conscious awareness of the content and flow of what I'm saying or writing. It's this awareness that is probably easiest to develop, as opposed to retracing your steps and trying to relearn the English language in a more formal way. Find several cover letters or business emails you've sent in the past and read them aloud. Do you feel like yourself as you read the words, or does it seem that you're trying to be someone else? Do they sound anything like how you would express yourself around people with whom you're comfortable? Don't get me wrong—I don't say "with whom" a whole lot in conversation—we do have to make certain adjustments in order to avoid the blatantly sloppy grammar that many of us use in daily speech. But, if I'd written "Is this anything like the manner in which you would express yourself around people with whom you're comfortable?" I think I would have gotten a bit too far from my communication comfort zone—and it would have given you an inaccurate impression of my personality.

As in music, when you might emphasize different aspects or colors of your tone depending on the music, context is an important consideration in business dealings as well. Who are you talking to? What are you asking of them? How well do you know them? What is their personality and what are their standards of formality? What are their needs? What does the "music" (the situation) call for? Considering these questions and adjusting your approach based on their answers does not make you an insincere person. You're simply listening (whether using your ears for spoken communication or your eyes for written communication) to what is around

you and bringing the various aspects of your personality to bear on the situation as appropriate. Playing loud may be your favorite, most natural musical expression—but that doesn't mean you're being phony if you play soft when it's appropriate. Different dynamics are required at different times, and you need to be able to use the full palette.

Rather than re-inventing the wheel every time you need to send correspondence about yourself, you may find it helpful to carefully craft several different text "blurbs" that can be used in your most common emails and solicitations. You can then draw upon this collection of blurbs to construct any given type of correspondence, adding a bit of customization where appropriate. Examples include a short version of your bio, a couple of paragraphs to use for pitching clinics, quartet or jazz combo concerts, and a paragraph about your orchestral experience. You can also compile a list of "go-to" quotes and video links so that you don't have to spend time and effort to find these assets each time you need to use them. Here are some examples drawn from materials I use with my clients:

PEDROSAXO—BIO (SHORT VERSION)

Pedrosaxo has revolutionized the saxophone. He has synthesized his many interests—imitation, acting, video gaming, and composition into a breathtaking and truly unique artistic statement. Quite simply, he has obliterated all previous technical and artistic boundaries, and has achieved it in ways that are fascinatingly beautiful, haunting, appealing, and awe-inspiring. An honors graduate of the Conservatory of Granada, Spain (and now living in Nashville, TN), he appeared as a finalist on Spain's nationally televised "Spain's Got Talent!" and has performed throughout the United States, Europe, and Asia.

Praise for Pedrosaxo

"Pedrosaxo is the Bobby McFerrin of the saxophone!"

~ Jeff Coffin

"Very unusual and hauntingly beautiful."

~ Bob Mintzer

"It appears that from the purely technical side Pedro has crossed into new territory on the saxophone. The implications are vast and pose a challenge to all saxophonists no matter the idiom."

~ Dave Liebman

"I have never seen anything like this . . . this is different."

~ Paquito D'Rivera

28 Chapter Five: Tone & Musicality - *Finding Your Voice*

> "... You cannot believe his impact on the public, the other teachers and the students. You have to see him 'LIVE'! Pedrosaxo has developed a very original, special and particular style of musical performance..."
>
> ~ Arno Bornkamp

PEDROSAXO PR COVER LETTER

In this sample media pitch, sent to potential CD reviewers, I've used the above bio blurb and quotes and added additional text in the first and last paragraphs.

Hello,

I've enclosed the self-titled debut CD from Spanish saxophone phenom Pedrosaxo (Pedro Rafael Garcia Moreno), produced by Jeff Coffin (Dave Matthews Band saxophonist and 3× Grammy Award-winner with Bela Fleck & the Flecktones). The CD *PEDROSAXO* is set for release March 11, 2014, on Ear Up Records. We believe you'll find that you have never heard anything quite like this recording. It is worth noting that these are all single takes with no overdubs.

An honors graduate of the Conservatory of Granada, Spain (and now living in Nashville, TN) Pedrosaxo has revolutionized the saxophone. He has synthesized his many interests—imitation, acting, video gaming, and composition into a breathtaking and truly unique artistic statement. Quite simply, he has obliterated all previous technical and artistic boundaries, and has achieved it in ways that are fascinatingly beautiful, haunting, appealing, and awe-inspiring. He appeared as a finalist on Spain's nationally televised "Spain's Got Talent" and has performed throughout the United States, Europe, and Asia.

PEDROSAXO is the result of many years and countless hours of development, perseverance, and artistic distillation. I hope you'll consider covering and/or reviewing this exciting and historic 2014 release (coincidentally the 200th anniversary of the birth of Adolphe Sax). Pedro is available for interviews by request.

Please visit www.pedrosaxo.com for more information.

Thank you for your time and consideration!

Sincerely,

Brian Horner

Praise for Pedrosaxo

"Pedrosaxo is the Bobby McFerrin of the saxophone!"

~ Jeff Coffin

"Very unusual and hauntingly beautiful."

~ Bob Mintzer

"It appears that from the purely technical side Pedro has crossed into new territory on the saxophone. The implications are vast and pose a challenge to all saxophonists no matter the idiom."

~ Dave Liebman

"I have never seen anything like this . . . this is different."

~ Paquito D'Rivera

". . . You cannot believe his impact on the public, the other teachers and the students. You have to see him 'LIVE'! Pedrosaxo has developed a very original, special and particular style of musical performance"

~ Arno Bornkamp

TRACY SILVERMAN—BIO

Lauded by the BBC as "the greatest living exponent of the electric violin," Tracy Silverman's groundbreaking work with the 6-string electric violin defies musical boundaries. The world's foremost concert electric violinist, Silverman was named one of 100 distinguished alumni by the Juilliard School.

Formerly first violinist with the innovative Turtle Island String Quartet, Silverman has contributed significantly to the repertoire and development of what he calls "21st century violin," the 6-string electric violin. His work with the instrument has inspired several major concertos composed specifically for him, including Pulitzer-winner John Adams' "The Dharma At Big Sur," premiered with the Los Angeles Philharmonic at the gala opening of Walt Disney Concert Hall in 2003 and recorded with the BBC Symphony on Nonesuch Records with Adams conducting. Legendary "Father of Minimalism" Terry Riley's electric violin concerto, "The Palmian Chord Ryddle," was premiered by Silverman with the Nashville Symphony in Carnegie Hall in 2012 and recorded by Naxos Records, and Kenji Bunch's "Embrace" concerto was co-commissioned by nine orchestras and premiered by Silverman in 2014. Silverman's 2014 recording

30 Chapter Five: Tone & Musicality - *Finding Your Voice*

for Delos/Naxos Records, *Between the Kiss and the Chaos*, features the Calder Quartet collaborating on Silverman's 2nd electric violin concerto of the same title, and he'll follow that up in 2015 with the premiere of the full orchestra version of Nico Muhly's "Seeing Is Believing."

Tracy's solo show, *Concerto for One* (and duo version *Concerto For Two*, featuring 5× Grammy-winning percussionist Roy "Futureman" Wooten), explores the limitless possibilities of "21st-century violin playing" and synthesizes his eclectic background in classical, rock, jazz, and world music into a genre-bending performance of stylistic breadth and emotional depth. Utilizing electronics and live loop recording, solo arrangements of his concerto repertoire come to full symphonic life. The show also includes a few choice extras by anyone from Jimi Hendrix to Beethoven to Bach along the way.

The *Chicago Tribune*'s John von Rhein hailed Silverman's "blazing virtuosity" and the *New York Times*' Anthony Tommasini admired his "fleet agility and tangy expressivity." "Inspiring. Silverman is in a class of his own," wrote Mark Swed of the *Los Angeles Times*. Silverman tours internationally as a soloist with orchestras, with his one-man performances, and as a collaborator with many artists and chamber ensembles. Tracy teaches at Belmont University and lives in Nashville, TN.

TRACY SILVERMAN—NICO MUHLY COMMISSIONING CONSORTIUM INVITATION

This invitation letter was sent to orchestra artistic administrators inviting them to consider a commissioning project. It utilizes much of the bio, with a custom paragraph about the project at the beginning (and added information about the composer).

Dear _____:

I'm writing to invite you to join a consortium that will commission Nico Muhly to write a full-orchestra version of his chamber work "Seeing Is Believing," a concerto for electric violin. I envision a consortium comprised of six to ten orchestras (which will keep the buy-in very modest), and I'm open to their input regarding the timeframe for premieres. Muhly was recently praised by Anthony Tommasini of the *New York Times* following the American debut of his opera, "Two Boys," by the Metropolitan Opera: "It is hard to describe what makes a composer's voice authentic. But you know it when you hear it. Nico Muhly has a voice, a Muhly sound." The soloist will be Tracy Silverman, lauded by the BBC as "the greatest living exponent of the electric violin."

Formerly first violinist with the innovative Turtle Island String Quartet, Silverman was named one of 100 distinguished alumni by the Juilliard School. Shortly after graduating in 1980, Silverman built one of the first-ever 6-string electric violins and set his own course as a musical pioneer, designing and performing on an instrument that did not previously exist.

Silverman has contributed significantly to the repertoire of the electric violin, inspiring several major concerti composed specifically for him, including Pulitzer winner John Adams' "The Dharma at Big Sur," premiered with the Los Angeles Philharmonic at the gala opening of Walt Disney Concert Hall in 2003 and recorded with the BBC Symphony on Nonesuch Records with Adams conducting. Legendary "Father of Minimalism" Terry Riley's "The Palmian Chord Ryddle" was premiered by Silverman with the Nashville Symphony in Carnegie Hall in 2012, and Kenji Bunch's "Embrace" concerto was co-commissioned by nine orchestras through Community Engagement Lab and premiered by Silverman in 2014. You can read more about Tracy at www.tracysilverman.com.

Nico Muhly has composed a wide scope of work for ensembles, soloists, and organizations including the American Symphony Orchestra, Boston Pops, Carnegie Hall, Chicago Symphony, countertenor Iestyn Davies, violinist Hilary Hahn, choreographer Benjamin Millepied, New York City Ballet, New York Philharmonic, Paris Opéra Ballet, soprano Jessica Rivera, and designer/illustrator Maira Kalman.

Muhly has worked frequently with Bedroom Community, an artist-run label headed by Icelandic musician Valgeir Sigurðsson. Bedroom Community began in 2007 with the release of Muhly's first album, *Speaks Volumes*. In spring 2012, Bedroom Community released Muhly's three-part *Drones & Music*, in collaboration with pianist Bruce Brubaker, violinist Pekka Kuusisto, and violist Nadia Sirota.

Born in Vermont in 1981 and raised in Providence, Rhode Island, Muhly graduated from Columbia University with a degree in English Literature. In 2004, he received a Masters in Music from the Juilliard School, where he studied under Christopher Rouse and John Corigliano. You can find more information about him at www.nicomuhly.com.

Please let me know if this is something you'd like to discuss further. Thank you for your time and consideration.

Sincerely,

Brian Horner

ANNIE SELLICK—CLINIC PITCH

Based on Annie's short bio, this letter is an approach to a potential clinic venue such as a college.

Dear _____,

I work with renowned vocalist Annie Sellick. She's going to be on tour in your area in October and would love to come in and work with your students. In addition to being one of the hottest young singers on the scene today—JazzTimes calls her "so uniquely gifted that preeminence seems a foregone conclusion" and groups her into the same "elite circle" as Madeleine Peyroux, Jackie Ryan, Roberta Gambarini, and Kat Edmondson—Annie has a passion for sharing her skills, experience, and perspective with students. As an independent artist who has handled all aspects of her career she can teach not only about her performance skills but also about the skills necessary to even make it to the stage. She presents clinics on "how to pick up a band on the road," jazz phrasing, and group vocal improv. She also has a moving and encouraging 17-minute, one-woman show called "What Is An Artist?" that explores the challenges we all face in this business and gets to the core of why we do what we do.

"What Is An Artist?" is a great lead-in to a workshop and discussion about all that goes into pursuing a career as an artist, whether as a singer or instrumentalist. We can work with you to develop a schedule for the day that addresses yours and your students' needs and integrates a workshop and performance.

Annie has performed all over the country as well as throughout Europe, Japan, and Canada. She was the featured vocalist for Mark O'Connor's Hot Swing Tour, has recorded albums with Joey DeFrancesco and the trios of Gerald Clayton and Jeff Hamilton, and was featured in a sold-out "A Night Of Jazz" performance with the Nashville Symphony. Her accolades go on and on and her charisma does not disappoint.

Let me know if this is something you'd like to discuss further. Thanks for your time and consideration!

Praise for Annie Sellick

". . . Sellick's most attractive quality may be the manner in which she has transformed her influences into her own immediately identifiable style."

~ Los Angeles Times

> *"Annie Sellick has the most pleasing standards voice I've heard in a long time."*
>
> ~ The Village Voice

> *". . . her rendition of emotionally complex songs is masterful . . . she is also a stunning visual performer."*
>
> ~ L.A. Jazz Scene

ANNIE SELLICK—CONCERT PITCH

You'll see much of the same language as above, minus the references to educational offerings. This was sent to a person that I knew so it is a bit shorter and less formal.

Hi _____,

I work with vocalist Annie Sellick. I'm working on putting together a Florida tour for her and her trio this summer. In addition to being one of the hottest young singers on the scene today—JazzTimes calls her "so uniquely gifted that preeminence seems a foregone conclusion" and groups her into the same "elite circle" as Madeleine Peyroux, Jackie Ryan, Roberta Gambarini, and Kat Edmondson—Annie performs with a trio of equally impactful players. Drummer Justin Varnes (Mose Allison, the Earl Klugh Trio), bassist Elisa Pruett (Kenny Barron, Wycliffe Gordon), and pianist Joe Davidian (Chester Thompson Trio) complement and augment her honest and soulful interpretations.

Annie has performed all over the country as well as throughout Europe, Japan, and Canada. She was a featured vocalist for Mark O'Connor's Hot Swing Tour, has recorded albums with Joey DeFrancesco and the trios of Gerald Clayton and Jeff Hamilton, and was featured in a sold-out "A Night Of Jazz" performance with the Nashville Symphony. Her accolades go on and on and her charisma does not disappoint.

You can see and hear more at www.anniesellick.com and www.youtube.com/anniesellick.

Let me know if this is something you'd like to discuss further. Thanks for your time and consideration!

Praise for Annie Sellick

". . . Sellick's most attractive quality may be the manner in which she has transformed her influences into her own immediately identifiable style."

~ Los Angeles Times

"Annie Sellick has the most pleasing standards voice I've heard in a long time."

~ The Village Voice

". . . her rendition of emotionally complex songs is masterful . . . she is also a stunning visual performer."

~ L.A. Jazz Scene

ANNIE SELLICK—MEDIA ALERT TO PUBLICIZE CONCERTS

Again, the same language from both of the other letters, plus a custom paragraph about this particular concert's details (which is its own blurb that can be reused by substituting date, time, venue, city, price, venue website).

JAZZ CHANTEUSE ANNIE SELLICK & TRIO AT RED CLAY THEATRE OCTOBER 17

FOR IMMEDIATE RELEASE

Duluth, GA (September 24, 2013)—Nationally renowned jazz vocalist Annie Sellick will perform with her trio at 8 p.m. on Thursday, October 17, at the Red Clay Theatre in Duluth, GA. Tickets are $15–17 and can be purchased at www.eddieowenpresents.com.

Annie Sellick is one of the hottest young singers on the scene today—JazzTimes calls her "so uniquely gifted that preeminence seems a foregone conclusion" and groups her into the same "elite circle" as Madeleine Peyroux, Jackie Ryan, Roberta Gambarini, and Kat Edmondson. And she performs with a trio of equally impactful players. Drummer Justin Varnes (Mose Allison, the Earl Klugh Trio), bassist Elisa Pruett (Kenny Barron, Wycliffe Gordon), and pianist Joe Davidian (Chester Thompson Trio) complement and augment her honest and soulful interpretations.

Sellick has performed all over the country as well as throughout Europe, Japan, and Canada. She was a featured vocalist for Mark O'Connor's Hot

Swing Tour, has recorded albums with Joey DeFrancesco and the trios of Gerald Clayton and Jeff Hamilton, and was featured in a sold-out "A Night Of Jazz" performance with the Nashville Symphony. Her accolades go on and on and her charisma does not disappoint.

You can see and hear more at www.anniesellick.com, including downloadable media assets.

Annie is available for phone and live interviews as schedule permits.

Praise for Annie Sellick

"... Sellick's most attractive quality may be the manner in which she has transformed her influences into her own immediately identifiable style."

~ Los Angeles Times

"Annie Sellick has the most pleasing standards voice I've heard in a long time."

~ The Village Voice

"... her rendition of emotionally complex songs is masterful ... she is also a stunning visual performer."

~ L.A. Jazz Scene

JOHN MOCK—BIO

John Mock is an artist, and the ocean and its coasts are his muse. From his native New England to the shores of Ireland and Scotland, John captures in music and story the heritage of the sea.

Whether appearing solo, with string quartet, or with a symphony orchestra, John shares this heritage through his captivating concert presentations, "From Sea To Shore," and "Portrait of Ireland." John's performances on guitar, concertina, mandolin, and tin whistle are further enhanced by his narration and storytelling, which bring to life the characters and places that inspire his music. A multimedia version of the concert is also available, in which John's own photography is projected, providing a beautiful backdrop for the music.

Widely sought after as a composer, arranger, and multi-instrumentalist, John has worked with such notable artists as the Dixie Chicks, James Taylor, Dolly Parton, Nanci Griffith, Maura O'Connell, Sylvia, Kathy Mattea, and Mark O'Connor. John's credits as composer and featured soloist include performances with the Nashville Chamber Orchestra, the Nexus Chamber Orchestra, the Nashville Philharmonic, the Southwest Michigan Symphony Orchestra, and the National Orchestra of Ireland. He has also worked extensively across the country as a solo performer.

JOHN MOCK—ORCHESTRA CONCERT PITCH LETTER

Utilizes much of the bio above. This letter, sent following an initial email exchange where the recipient requested more information, also uses a few words added specifically because it was sent to an orchestra: "Celtic," "audience-pleasing," and "economical." And "educational programs" are mentioned as they are typically of interest to orchestras and enhance the proposal (assuming that the artist is a genuinely capable and engaging educator).

Dear _____,

I've enclosed two CDs from composer, multi-instrumentalist and photographer John Mock. As I mentioned in my email, John presents a unique symphony pops concert called "From Sea To Shore". The concert features his original folk-classical music inspired by coastal scenes that he has also photographed. He performs his instrumental works on guitar, mandolin, concertina, and tin whistle, with his exquisite photography projected onto a screen behind him. His casual narration and story-telling tie it all together. With a bit of Celtic flair and beautiful melodies that evoke the romance and majesty of the Atlantic coasts from New England to Ireland, this show provides a unique, audience-pleasing, and economical pops offering. Accompanying educational programs are available as well.

You can find more information on John, his music and photography at www.johnmock.com.

Widely sought after as a composer, arranger, and multi-instrumentalist, John has worked with such notable artists as the Dixie Chicks, James Taylor, Dolly Parton, Nanci Griffith, Maura O'Connell, Sylvia, Kathy Mattea, and Mark O'Connor. John's credits as composer and featured soloist include performances with the Nashville Chamber Orchestra, the Nexus Chamber Orchestra, the Nashville Philharmonic, the Southwest Michigan

Symphony Orchestra, and the National Orchestra of Ireland. He has also worked extensively across the country as a solo performer.

Please let me know if this is something you'd like to discuss further!

Sincerely,

Brian Horner

CHAPTER SIX

Articulation
Attention to Detail

As my saxophone students can attest, articulation is one of my central pet peeves. Just as the composer has indicated which notes to play, he or she has also indicated the articulations that, executed correctly, will help to convey the texture, momentum, and line of the phrase. To ignore those markings is to deprive the music of part of its character and to relegate it to sounding a bit more like everything else. Perhaps of equal importance is that it also shows a lack of care and attention on the part of the musician. This sort of attention to detail is one of the most important values that the musician must bring to business dealings as well.

This is a fairly important concept—I'm referring to everything from keeping your calendar straight and arriving for gigs and rehearsals at the correct time to double-checking the spelling in your outgoing emails and texts. Take extra time and care—avoid the temptation to ignore the markings and "just slur everything!"

I'll focus on three main areas where "the Devil's in the details:"

- Typos and spelling errors in correspondence and promotional materials
- Calendar/scheduling mistakes
- Tour preparation

Typos and Spelling Errors

In correspondence . . .

Professional letters, emails, and even texts are probably the places where it's most likely that you'll make a typo that could have a negative effect on the impression you're trying to make. The most serious of these would be the misspelling of the recipient's name, followed by the misspelling of something that you're referring to in the text—a piece of music, a colleague, a shared acquaintance, and so on. Then there's the common typo that results in a misspelled word or, if you're unlucky, changes the

meaning of your sentence. For example, after texting back and forth with an orchestra administrator about who would pay travel expenses for an upcoming client engagement, I almost sent a text saying that I might travel in for the show but assuring him that he didn't need to "lay me." Awkward. Luckily, the habit of re-reading outgoing texts before hitting send allowed me to change it to the much more appropriate "pay!"

And the fix is as simple as that. Set a rule for yourself that you'll always pause before hitting "send" to re-read your email, text, or letter, as well as the name and address listed in the "to" field (auto-fill is often the culprit here). I'm often moving so fast that small mistakes are likely and common. Taking the extra minute to slow down and double-check myself is more than worthwhile.

In promotional materials . . .

Through the course of building your business you'll create many different promotional materials, from resumes, onesheets, and business cards, to CD packages, press releases, and posters. Mistakes that make it to print can be costly, both in terms of making a negative impression and having expensive materials that you're unable to use. Make a strong habit of proofreading all drafts of every piece you create. Print out the text and proof it, making your markups by hand. I read the text to myself slowly and deliberately as if I'm a first-grader, focusing on each word, and if time allows, I take a break between readings. Make the corrections to the file and then repeat the process before sending to the printer. If you're working with a graphic designer, proof each version or generation of the piece. It's tedious work, especially by the third or fourth time you've proofed the same block of text, but you'll find that it is worth it in the long run.

The appendix contains a few samples of artist promotional materials.

Calendar/Scheduling Mistakes

Hopefully you will become so busy that your calendar is a crowded place. Whether you use an old-fashioned planner or Google Calendar, I hope your weeks are a tangled mass of rehearsals, concerts, and business meetings. However, to get to this point you're going to need to have the ability to keep things straight. Having to back out of commitments because you've double-booked yourself and arriving late to rehearsals or gigs because you've written down the wrong times are a couple of the things that will set you apart from the competition—negatively. This is a great example of a seemingly simple skill, especially when compared to mastering a piano sonata, that can literally be the difference between launching and maintaining a career or not, regardless of your level of skill.

As I mentioned before, your ability to play the right notes in tune at the right time is a given. All of your serious competition can be relied upon to do that. Being in your seat and fully prepared at the correct time—without fail—is an attribute that will help you make the cut.

It's helpful when managing your calendar to make sure that you have a record of all engagements in writing. Email is helpful in this regard as it automatically maintains a record of all correspondence. When accepting a gig (or lesson, etc.), make a habit of re-typing the date, time, location, dress, pay information, and any other pertinent details in an email to the person hiring you, rather than relying on your memory of a phone call. For more formal gigs, contracts can help serve the same purpose. While they may or may not be the ultimate legal protection for a gig, they list all of the details and the expectations of both sides in one clearly organized document.

In addition to carefully recording the concrete details of any engagement, it's equally important to plan for the variable details. Excuses involving traffic, car or navigation problems, or other delays don't really work on the professional level. Consider all factors when planning your commute (are you headed into the city during rush hour?) and have a strict rule that has you arriving early for any kind of engagement. The amount of extra time you'll need to allow will vary according to how long a drive or commute you have and a number of other factors that only you can assess. This habit will provide a cushion that will protect you from all but the most disastrous of scenarios and will prevent a situation where you're running into the room right before the downbeat in a frenzied panic.

Tour Preparation

Traveling for a show or group of shows requires an advanced level of planning due to the much greater number of variables. Where will you stay? How long will it take to get from the airport to the hotel and from the hotel to the venue? How much will the trip cost (compared to the amount the trip will earn)? You must be able to anticipate the costs and logistics that will be relevant throughout the entirety of the trip. Completing a comprehensive itinerary and budget will help you in this process—use a template that will prompt you to answer all of the necessary questions. The process of creating the itinerary should begin when you confirm the gig. Along with your confirmation, send the buyer (the person hiring you) a tour advance checklist—a list of fill-in-the-blank questions that will give you the vast majority of the necessary information (below is a completed sample; a template is included in the Appendix). You'll use this information to complete your itinerary.

Completed Sample Tour Advance Checklist

TOUR ADVANCE CHECKLIST	
ARTIST:	Brian Horner/Elizabeth Avery/M. Zachary Johnson
CONCERT DATE:	2/20/2010
CITY:	Washington, GA
VENUE:	Bolton Lunceford Playhouse
VENUE ADDRESS:	North Alexander Avenue, Washington, GA 30673
TIME ZONE:	Eastern
VENUE CONTACT (NAME/PHONE/EMAIL):	[contact info]
DAY OF SHOW CONTACT (IF DIFFERENT):	same
PARKING INFO:	small lot to the right of building
LOAD-IN TIME:	3:00pm
SOUNDCHECK TIME:	4:00pm
CONCERT TIME:	8:00pm
NUMBER/LENGTH OF SET(S):	two 45-min sets; 15-min intermission
FOOD PROVIDED:	yes, dinner at local restaurant; snacks backstage
MERCH SALES TERMS:	100% to artist
HOTEL/LODGING:	provided
NOTES:	hotel is short walk from theatre

Sample tour itinerary (one day)

Feb 7 (Th) **The Blue Wisp—Cincinnati, OH—7:30 p.m. & 9:15 p.m. 700 Race Street, Cincinnati, OH 45202 (corner of 7th and Race)**

Travel to Cincinnati—1 h 40 min, 100 min

Venue phone: (513) 241-WISP
Day of show Contact (name, cell):
Day of show contact email:
Load-In time: 4:00 p.m.
Soundcheck: 6:00 p.m.
Concert—number of sets/times: 7:30 & 9:15 p.m.
Loaders: yes, club guys
Parking: next to the club on 7th Street
Food: provided—order from menu
Merch: artist keeps 100%
Backline available: grand piano, drum kit
Distance—hotel to venue: 1 m (next door)
Hotel (provided by venue):
Garfield Suites
Two Garfield Place
Cincinnati OH 45202
(513) 421-3355
CONFIRMATION # (room 1): X4717
CONFIRMATION # (room 2): X4716
CONFIRMATION # (room 3): X4715

Sample tour budget

Income

May 5 (Mo)	Venue 1	Atlanta, GA	$2,450
May 6 (Tu)	Travel	Nonstop flight—Atlanta to San Francisco	
May 7 (We)	Venue 2	Saratoga, CA	$1,200
May 7 (We)	Venue 3	San Francisco, CA	$3,500
	Venue 3 hotel buyout		$ 800
May 8 (Th)	Venue 4	Santa Cruz, CA	$3,500
	Venue 4 hotel buyout		$ 300

44 Chapter Six: Articulation - *Attention to Detail*

May 9 (Fr)	Venue 5	Bakersfield, CA	$ 7,000
		Total	$18,750
Expenses			
Air outbound	$1,245	$207.50 each (6 tickets)	
Air return	$1,330	4 tickets @ $211.50, 1 @ $216.50, 1 @ $223 plus $45 baggage	
Backline	$0		
Hotel 5/5	$113	for extra driver	
Hotel parking 5/5	$10		
Hotel—5/6 and 5/7	$1,518		
Hotel 5/8	$294		
Hotel at LAX—5/9	$375		
Vehicle rental—CA	$855		
Gas—CA	$180	450 min/12 mpg × $4.75	
Gas—to ATL round trip	$175	550 min/12 mpg × $3.75	
Extra driver to ATL	$100		
Agent 1 commission	$2,100		
Agent 2/ Manager commission	$1,065		
7% CA tax— Venue 3	$245		
7% CA tax— Venue 4	$245		
7% CA tax— Venue 5	$490		

Payroll—full days	$7,200	$300 × 6 × 4 days	
Payroll—travel days	$520	$40 × 6 × 2 days, plus half a day ($20 each) for 2 people on Friday 5/2	
Total	$18,060		
Profit/Loss	+$690		

The itinerary and budget above illustrate how many questions arise when planning a complicated tour (and these examples are actually from relatively simple "indie" tours) and they show an organized way to sort and answer these questions. The budget also shows how expensive touring can be and how much of the tour's earnings will go toward covering expenses. When building your itineraries and budget, double-check everything. Double-check the flight numbers and departure/arrival times, double-check the fees you've agreed upon, double-check the sound engineer's phone number, and on and on. There are always unexpected developments on the road but taking the time to concentrate on and double-check your details will set you up for as smooth a tour as possible.

I've included tour advance checklists and budget templates in the Appendix.

CHAPTER SEVEN

Scales
The Building Blocks of the Business

Scales are the building blocks of music, and from the very early years of any serious musician's musical life they have been told the importance of learning and practicing scales. This chapter presents a wide-ranging overview of the building blocks of the music business.

Part One—The DIY Approach . . .

The focus of this first section will be on the nuts and bolts of the business as it pertains to independent artists, regardless of genre. In keeping with the scale analogy, I'll focus on twelve key areas (get it?):

Recording—I want to make an album when I grow up . . . wait, I am grown up

I absolutely love the recording process. You get to make something from nothing—you get to see the music that you play appear on a computer screen as graphically represented sound that is captured forever. Whether you're interested in making a recording to use as a demo or to release as your debut album, there are many more options available to you than there were 30 years ago.

There are more and more recording engineers who have installed studio equipment in their homes. They often have great gear and use the same recording software found in major studios. Though it may not seem as glamorous as working in a "real" studio, the product can be just as good—and much more affordable. Often an owner of a home studio is a recording engineer and will combine the traditional hourly rates for studio rental and recording engineer into a single rate that is less expensive than the two would have been separately. Another affordable alternative to a recording studio is a good acoustic space, such as a church, that is willing to allow you to work for free or for an exchange of services (perhaps you could

perform during a church service, etc.). Many recording engineers are willing to set up gear (which is now smaller and more portable) and record in a remote setting.

You can also experiment with learning to record yourself. There are some high quality and affordable digital recorders available now in the $100–500 range. ZOOM makes a series of recorders including at least one that is capable of multi-track recording and another that is also a video recorder. Although this option is probably more appropriate for recording a demo than an album, the quality of these recorders is amazing.

As with anything, time is money and preparation is everything. The people you'll be working with are "on the clock." You should have a plan for the recording session or sessions—an order in which you plan to record the music, and so on—and arrive physically and mentally prepared to make the most of your time.

Distribution—The world is literally at your fingertips

Many people think that you need to be signed to a record label in order to release an album. As you may be aware, this is no longer true. For the vast majority of independent artists it is wiser to release the album themselves. Unless there is a label interested in bringing something truly meaningful to the table in the form of a financial advance (very rare) or a significant advertising/PR/marketing budget (also very rare), you will be just as well off keeping your album, creating a label, and releasing it yourself. The creation of a label can be as simple as choosing a name that refers to a business that you operate as an individual "doing business as" or "d/b/a." Your CDs will cost you less than $2 each to manufacture yourself, whereas you would have to buy them from a record label for $5–10. Interestingly, it has been my experience that many of the smaller labels rely on the artists themselves to buy the product and sell it to their audiences at shows—the artist literally purchases most of the albums himself and acts as the de facto distributor. You can see why it might be advantageous to do all of this yourself.

Disc Makers (discmakers.com) is the leader in independent manufacturing. You can order your CDs in virtually any type of packaging, from cardboard sleeves to jewel cases to multi-CD packages. They also offer posters, stickers, download cards, and a number of other indie-artist support resources. You can access templates that will help you or your designer to configure the album package graphics to the manufacturer's specifications.

I recommend selling your physical CDs at CD Baby (cdbaby.com). The setup process is easy and the site offers plenty of tools for interfacing with your own website and social media sites. It also has relationships with wholesalers so that if there is interest in your album the pathways

exist for your CDs to be carried in bigger stores (though obviously there are fewer and fewer "bigger stores" that sell anything but the biggest of hit albums). CD Baby charges a one-time setup fee (no annual fees) and keeps a flat rate (currently $4 per CD) per CD sold.

There are two main options for digital distribution, Tunecore (tunecore.com) and CD Baby. Both will place your music on iTunes and at every other significant digital retailer in the world. The main difference is that Tunecore charges an annual fee and allows you to keep 100% of your sales revenue, whereas CD Baby charges a one-time setup plus a flat fee per sale, as I've described above. Based on your sales expectations you can calculate which scenario will be more advantageous.

Marketing—A game plan

"Marketing" refers to everything you do to put your music in front of other people. It includes your online profile (website, social media), press releases you send to the media, download cards you give away at concerts or other events, and advertising (of any kind)—you name it. I think that the most important exercise for the marketing of your album is to imagine the people who make up your audience. Are they young or old? Do they consume music digitally? Do they discover music through their friends or from reviews in magazines? You can't know with certainty the answers to these questions, but if you can conjure a clear picture of the type of person you're trying to reach—your demographic—then you can make educated guesses. This makes the task of approaching your audience much more manageable.

Once you have completed this exercise, you can target your marketing accordingly and put your music in places where it is likely that it will be discovered or purchased by your audience—blogs, online radio, terrestrial radio, satellite radio, newspapers, magazines, e-zines, community newsletters, trade and specialty publications, doctor's offices and nursing homes, nursery schools, and so on.

A valuable tool in the marketing of an album is a well-organized marketing plan. The plan is an outline that will include categories for the various types of marketing you'll pursue, such as publicity, social media, e-commerce, radio promotion, touring, and so on. Put it all in writing and in one place so that you can see the overall strategy. This plan can grow and evolve and be constantly changing.

Publicity—If an album is released and nobody hears it, does it make a sound?

Publicity is one of main components of any marketing plan, and there are two main "products" you'll be publicizing—your recordings and your

live concerts. Social media plays a huge role in getting the word out about anything and you're probably very familiar with using that tool. In addition to using routine social activity to spread the word, Google AdWords and Facebook ads are also worth investigating. Generally speaking, you set a budget (any amount you want) and you pay a pre-determined price every time someone clicks on your ad. When your budget has been exhausted the ads stop appearing. Based on the ad's content, Google and Facebook figure out how to have the ad appear in the right places (i.e. in front of people who are inclined to be interested).

Most mainstream media outlets have contact or submission information on their websites. You have to dig up the info and build your lists. You can almost always find staff listings through the "Contact" or "About" buttons. If not, pick up the phone and call. Again, focus on where your likely audience is and how they get their information. For example, it may not be realistic to send a press release about your new album to every daily newspaper in the country, but you should certainly include your current city and the cities where you grew up and went to college. There are also trade organizations that may offer mailing lists for sale. Examples of these organizations include the North American Saxophone Alliance, International Trumpet Guild, Folk Alliance International, League of American Orchestras, Jazz Education Network, New Music USA, and Musical America. There are many others and they all offer various resources and perhaps even annual conferences that offer exhibiting and networking opportunities.

Depending on your budget you can hire an independent publicist who specializes in your genre. They have already built large networks of contacts and relationships that allow them access to reviewers and other decision-makers. The fee range is fairly broad for these services—it can be relatively inexpensive and it can be exceedingly expensive. Results are not guaranteed and PR exposure does not necessarily have an impact on sales so it is important to understand your short and long-term goals when you make this sort of investment.

Booking—I just want to play shows

How do I book shows? That is the million-dollar question (or maybe the $200 question!). There's not an easy or short answer because it is hard work. In any genre there are lots of good artists who all want the same thing. It can be frustrating as an artist when booking agents and venue owners (presenters) don't seem to be able to see how good you are and how much their audience would love your concert. But it's important to try to see things from their perspective as well. "They" are businesses and in order to keep the lights on they need to make sound business

decisions—decisions that will result in making money. So it always comes down to how many people you will "draw"—how many people will pay to hear you play. That is the question that the venue will ask you when you approach them about getting a gig and that is the question that the booking agent will ask you when you approach him about getting you a gig. Everyone wants and needs to know "what's in it for me." That's not greedy, it's just business. There's a saying that "it's not called 'show friends,' it's called 'show business.'"

Therefore, the best thing you can do for yourself is to work hard on your own to create that buzz and that interest in your music. If you can't get a venue to give you a slot, create a show yourself. Find a space—a church, school, frat house, friend's house, your house, wherever—and present a concert. Collect email addresses so that you can let people know about the next time you're playing and so that you can tell the venue how many people were interested enough to join your mailing list. Keep track of how many people came to the show. Do this in as many places as you can—this is the sort of thing that will set you apart and the effort will pay off. Feeling sorry for yourself and resenting agents and venue bookers will not!

Another worthwhile approach is to pursue opening slots. Often a venue and a touring artist are willing to add a local opener to the show particularly if that opener will bring in some of their own fans. You may not be able to bring in enough people to fill a 200-seat club, but your 25 fans will help fill the room when the touring artist may be falling just a bit short. Also, your hard work in promoting the show is a huge benefit to the artist and the club. I was able to get an opening slot for an artist at a renowned folk club in Boston based on the quality of the artist and my assurance that we would work hard to promote the show. I remembered that there was a writer for the *Boston Globe* that was interested in the artist and was waiting for an opportunity to pitch a story to her editor. Since we now had a show in Boston the writer could make the pitch. She did, and ended up writing a fairly large feature that appeared in the *Globe*. That was a huge help to the show and a huge piece of publicity for the artist. I don't remember what—if anything—the gig paid because it didn't matter! This is an example of the connectedness of various areas of the business and of the concept that if you lead by offering value it will often be valuable to you as well. Opening slots won't pay much but it's a win-win situation—you get to play for the other artist's fans and the artist and venue make a bit more money because of the added audience. This also allows the venue to see you perform and the new fans you collect at the show help make a future booking more likely. When pursuing an opening slot, try to figure out what benefit you can offer the artist and the club and tell them about it.

Contracts/Deal types—I was offered a door deal . . . what?

For the sake of clarity and mutual understanding, it is always a good idea to have a contract or letter of agreement that summarizes the terms of an engagement. It includes all of the relevant details such as name, address, and phone number of venue, name of the production contact, time for load-in and sound check, time and length of show, and more—I've included a template in the Appendix.

There are a few main types of deals—"door deals," flat guarantees, and guarantees with a "back-end split." Door deals are exactly what they sound like. You receive an agreed upon percentage of the money that is taken in by the venue in cover or ticket charges. This is by far the most common type of deal you'll encounter, particularly while you're working to build your fanbase. This deal allows a venue to present your show with minimal risk. You may think that there is no risk at all to the venue but it's important to understand that the venue has costs in the simple act of being open. They need to pay staff, buy food and beverages, and potentially forfeit a time slot that could have been more profitable with another artist. A common scenario would be something like "100% after $150" (though the amount could be $300 or more). The venue holds back the first $150 in this example to cover their cost of advertising or staffing (sound engineer, bar tender, etc.), and gives you the rest of the money that is received. Another scenario would be a simple split of the proceeds ranging from 50 to 90% for the artist. A flat guarantee means that you will be paid an agreed upon amount regardless of the money generated in ticket sales or cover charges. The upside is that you know the amount that you'll be making. The downside is that there is the theoretical possibility that the venue could make more money than you if the show sells well. To get past this risk you can ask for the third type of deal, a guarantee with a back-end split. This deal is a win-win and venues will often agree to it because it's fair and can be structured to allow the venue to recover any amount of expense that it incurs. An example of this kind of deal would be a $1000 guarantee plus 70% after $1250. This allows you to count on $1000 in income (and the venue has shared risk by committing to this). Once the venue has received that amount at the door, the deal then allows it to recover the rest of its expenses—$250 for advertising, sound engineer, and so on—and you both enjoy a share of the profits beyond that point.

Touring—I thought I was gonna make money?!

Done correctly, "hitting the road" is a very complicated endeavor that takes an enormous amount of advance planning. Once the dates are booked and publicized (already a significant amount of work) each one needs to be "advanced" and a budget needs to be compiled so that you can see exactly

how much money will be coming in relative to the amount you will need to spend to support the tour.

Advancing the dates involves emailing or calling the production contact at each venue (this may be the owner, the booker, or a production manager) and completing a checklist that covers all of the questions for which you need answers before you leave. Does the venue provide a sound system? If the venue is providing hotel rooms, where are they and what are the confirmation numbers? Is there a drum set you can use? Are there four chairs and music stands? You get the idea. The information compiled in your advance and through your contract can be used to complete an itinerary for the trip that provides all details in one document.

The budget, as you might expect, tracks all income against all expenses. You'll be surprised to see how much money flows out—how much it costs to tour. There are a number of items that you might not think to include, such as gas (where are you traveling and what is the price of gas in that part of the country, and what is the gas mileage of your vehicle?) or local entertainment taxes (California has a 7% tax on fees paid to out-of-state performers). Here is a sample budget for an indie band that had a run of fairly well-paid gigs. You'll see how little was left after everyone and everything was paid. Look this over carefully and you'll understand the flow (in and out) of money on a tour. Consider the similarities and differences between this tour and a hypothetical tour of your own.

Income			
Oct 28 (Tu)	TRAVEL		
Oct 29 (We)	Sandy Spring, MD	Venue 1	$ 2,500
Oct 30 (Th)	Reading, PA	Venue 2	$ 2,500
Oct 31 (Fr)	Amherst, MA	Venue 3	$ 600
Nov 1 (Sa)	Brattleboro, VT	Venue 4	$ 3,000
Nov 2 (Su)	Collinsville, CT	Venue 5	$ 1,250
Nov 3 (Mo)	South Hadley, MA	Venue 6	$ 1,600
Nov 4 (Tu)	Plains, PA	Venue 7	$ 1,500
Nov 5 (We)	Washington, DC	Venue 8	$ 2,500
Nov 6 (Th)	New York, NY	Venue 9	$ 2,500
Nov 7 (Fr)	Harrisonburg, VA	Venue 10	$ 1,500
Nov 8 (Sa)	Asheville, NC	Venue 11	$ 8,000
Nov 9 (Su)	Nashville, TN	Venue 12	$ 1,000
		Total income	$28,450

Expenses			
Agent commission (10%)	$2,845.00		
Manager commission (10%)	$2,845.00		
Air/train	$697		
Hotels	$1,633		
Road mgr	$2,640	8 gig days ($300), 1 clinic ($200), 1 travel day (Oct 28) ($40)	
Bandleader	$4,140	8 gig days ($300), 3 clinic days ($500), 1 clinic ($200), 1 travel day (Oct 28) ($40)	
Band member 1	$4,100	8 gig days ($300), 3 clinic days ($500), 1 clinic ($200)	
Band member 2	$2,640	8 gig days ($300), 1 clinic ($200), 1 travel day ($40)	
Band member 3	$2,600	8 gig days ($300), 1 clinic ($200)	
Band member 4	$2,640	8 gig days ($300), 1 clinic ($200), 1 travel day ($40)	
Gas	$825	2950 mi @ 13mpg @ $3.50 (plus $30 misc.)	
Total expenses	$27,605.00		
PROFIT/LOSS	+$845		

Tour advance checklist and budget templates are included in the Appendix.

Concert promotion—How do I let people know about my gig?

As products of the digital age you're probably able to spread news more easily than professional concert promoters could 30 years ago! Now that you have the gig, much of what you need to do to attract people to the show you will do through your social networks. As discussed earlier, pay-per-click (PPC) ads can be an effective addition to your social networking campaign. Collect email addresses from audience members at each concert and take the time to enter these addresses into your mailing list. There is software available, such as Constant Contact, which makes it easy for you to send newsletters and e-blasts alerting your audience to upcoming concerts. Design a professional, eye-catching 11×17 poster, leaving a 2×10 white, rectangular space at the bottom for each venue to add its own details. Print 100 or so of these (call around for the best deal on printing, or look online at uspress.com or uprinting.com) and send several to each venue a few weeks before each concert (you'll need to buy some mailing tubes as well—buy in bulk at uline.com). Build your own street team. Find a friend or fan in each place that you'll be playing and offer a free pair of tickets or a free CD in exchange for their help in promoting the show. Have them put up posters, make posts on their social networks, and spread the word among their friends. People are usually more than happy to do this and you can find them easily with a simple FB post. Thinking outside the box a bit, approach a restaurant near the venue and propose a partnership where each of you offers a discount so that you can offer a package deal where concert-goers enjoy dinner and a show. This way, you and the restaurant are each promoting the other and each enjoys additional customers that may be new to its brand. Get creative with this idea and customize it to fit whatever the context of your gig may be (i.e., maybe a restaurant isn't an appropriate partner but there is some other kind of business that may be).

Radio promotion—Is it even possible for an unknown artist to get on the radio?

As with publicity, discussed earlier, you can handle radio promotion yourself or hire a professional radio promoter if your budget allows. Radio stations are arranged by genre, or format. Each format has a chart that tracks the amount of airplay a given album or song receives. Promoters generally specialize in a single format, so that if you're a jazz artist you would hire a promoter who specializes in jazz radio. And this would be the focus of your research if you plan to promote your album yourself—it is possible. Start by determining what chart or charts track the format that is appropriate for your style of music. Staying with jazz as an example, JazzWeek and CMJ Jazz are the charts that track the format. Find out

what radio stations report to these charts, make a list, and get the contact information for each station. It'll take a while but when you're finished you'll know where to send your CDs to get them to the person who can actually decide whether or not to play it on the radio. Remove the plastic wrap from the CD so that the person receiving it doesn't have to (you can actually request that the manufacturer leave a certain quantity unwrapped for promotional purposes), and include a professional onesheet. Your onesheet should have all pertinent information on one . . . sheet. This will include an album cover graphic, track listing, barcode, highlight information on the artist and the musicians on the recording, past honors or accomplishments, a notation of recommended "focus tracks," and contact information. Follow up with an email or phone call 2 weeks after you've mailed the packages to make sure that they were received and to ask if the station would like any additional copies to use as giveaways (this can be a good way to get a few extra mentions on the air at minimal cost to you). Keep track of the results on a spreadsheet and make additional followups as necessary. The selection process can take several weeks so be patient and professional in your communications with the stations. Do not follow up more often than every 2 weeks, and no more than four times total (unless the contact asks you to keep in touch—if somebody tells me to "keep in touch" they'll have me as a friend for life!).

Now, radio airplay will not automatically result in album sales so you should not have that expectation. However, it will build your name recognition within the industry and among fans, and an appearance on the chart (which is possible for a new artist—I've see it happen with at least two of my artists) is a powerful credibility-builder that you can use to great effect in your press kit as you pitch yourself for concerts and other opportunities.

Copyrights, publishing, and royalties . . .
How does all of that work?

Your most important and meaningful assets as a composer or songwriter are your copyrights—your intellectual property. The world of copyright and publishing is amazingly complicated, but it's important to have at least a rudimentary understanding so that you can manage and protect these important possessions. I'm going to present only a brief overview in an effort to familiarize you with some of the main concepts. This topic could be its own book but it would require a different author!

A work is copyrighted when it is put down in a tangible form (audio recording, lead sheet, manuscript, etc.). That copyright is owned solely by the writer until and unless the writer shares it with or signs it over to a publisher. The publisher can be a publishing company that will work on your behalf to find placements for the composition (other artists who will record the song, or film/tv/video game placements, etc.), or it can

be a publishing company that you set up yourself (this is simpler than it sounds—you simply create a name for the company). Think of the ownership of a song or composition as being a pie. The writer owns half of the pie and the publisher owns half of the pie. When the writer is self-published that person owns the entire pie (writer's half plus publisher's half). When the song is written equally by three people, the writer's half of the pie is split equally among them and the publisher's share of the pie is split equally among their publishers (whether any of the writers is serving as his own publisher or not). The way a song is divided among its co-writers is referred to as its "splits"—that is, "what are the splits on that song?" The answer might be "writer one 50%, writer two 50%" (substituting actual names for "writer one" and "writer two"). In this example, if both writers are self-published (i.e., they "own their own publishing"), then they would each own half of the writer's share of the copyright and they would each own half of the publisher's share of the copyright—they would each own half of the entire pie. If they both had publishing deals with other companies (a company that owned their publishing), they would each own half of the writer's share and their respective publishers would own half of the publisher's share. Each writer would own 25% of the entire pie (and would be paid according to their publishing deals on the 25% of the pie that his publisher owned).

As a composer or writer it is important to affiliate with a performing rights organization (PRO). The main choices in the United States are ASCAP, BMI, and SESAC. Many writers have a preference for one of these companies over the others, so it would be best for you to talk to writers or composers that you know and ask about their experiences with their PRO and get their advice regarding which company to use. When you register you'll be asked to set up an account for yourself as a songwriter/composer and another account as a publisher (assuming that you do not have a publishing deal with another company). You're then able to register each of your works in your account. The PRO will collect licensing fees on your behalf from anywhere where your music is played—radio airplay, clubs, orchestra halls, and so on—and distribute the money to you and its other writers. You can also report your own performances of your material so that you can be paid on those performances as well. All venues pay a fee to the PROs that is divided among the writers whose works are determined to have been performed or broadcast in the venue. These earnings might amount to pennies or they might amount to thousands of dollars (or much more if you have a hit song or are a mainstream recording artist/writer).

It's also important to have your music registered at SoundExchange. According to its website, "SoundExchange is *the* independent, nonprofit performance rights organization that collects and distributes digital performance royalties to featured artists and copyright holders." It's important

to note that this applies to featured artists in addition to writers/publishers. SoundExchange holds your royalties so that you can collect even years after the money was generated. You can visit the site and set up an account. I've seen indie artists collect thousands of dollars through SoundExchange—money that they didn't even know was there.

Teaching—Those who *can* play . . . *and* teach!

You may well be familiar with this part of the business. Teaching private lessons is a good way for college students to make some money and also explore the pedagogy of their instrument. It is also a very viable way to make money after graduation. I spent 3 years making my living teaching private lessons, and it gave me the ability to have a flexible schedule and practice a lot. I was able to build a private studio of 35 students by contacting area band directors. I would tell them about my background and credentials and offer to visit their school and present a clinic for their students. I would then sign kids up for lessons. Often the schools will provide a space for private lesson instruction. I would visit four or five schools in rotation each week and had a steady supply of students. Schools with large marching band programs are usually good prospects. You can increase the amount of potential business by offering lessons on a greater number of instruments. For example, I taught beginning clarinet lessons in addition to lessons on saxophone, which is my main instrument. Flyers at music stores and social network advertising are also valuable tools in building your private studio.

Private lesson instruction is a relatively easy type of business to manage. Keep good records of your lesson schedule, the amounts paid by your students, and any business expenses you might have such as business mileage or equipment. I highly recommend putting a payment structure in place where the student is expected to pay for the entire month's lessons at the beginning of the month. You are relying upon this to pay your bills and this practice protects you from the many conflicts that can arise and prevent a student from making it to their lesson. Of course, you're able to be as flexible as you want and offer credit to a student if they are sick or have some other valid reason for missing their lesson, but this is a fair and standard requirement.

Creative revenue streams—Anything goes

I want to emphasize again that there are no rules in this new career you're building (okay, very few). Allow yourself to brainstorm creatively about possibilities that may exist . . . or may not yet exist. There are constantly new tools and online platforms emerging that allow you to share what you do in new ways. Your tour doesn't have to look a certain way

or only contain certain types of events. If you're able to book a show at a good venue but it doesn't pay enough to be viable on its own, then try to book a clinic at a nearby high school or college to supplement the day's income. Figure out how to offer online video lessons. If you see a nonmusic product being sold in an innovative or eye-catching way, imagine how that approach might be customized and applied to what you do.

My friend Jeremy McComb is a great example of this kind of thinking. He's a country singer-songwriter who tours around the country, but he also does concerts from his living room using a live webcast (stageit.com and concertwindow.com are two sites that facilitate this type of streaming). He calls it his "Almost Like A Real Tour Tour" and presents it regularly when he's home. It has become an event that his fans look forward to. You can set a "cover charge" for online events or allow fans to tip and pay what they want. He's able to interact with fans and develop and strengthen those all-important relationships.

The sky is the limit. Try. Fail. Try again.

Part Two—The do-it-with-others approach . . .

So far, the focus of this chapter has been on the business of a self-employed, independent artist. There are many other types of music careers as well. This next section provides an overview of the many people backstage and their roles in making it all work. These include orchestra administrators, the team members of a major recording artist, studio musicians, and record label executives.

Ensembles (orchestras, chamber orchestras)

In the United States, these organizations are usually not-for-profit corporations. That classification has a number of complicated implications, but generally it means that its tax liability is decreased, that it relies on a combination of earned income (ticket sales, etc.) and unearned income (donations, grants, etc.), and that patrons' donations will be tax-deductible. Depending on the organization's size, one or more of the following positions may be in place:

Executive Director—oversees and is responsible for all of the operations of the organization and generally serves as the leading "face" of the fundraising efforts.

Music Director—the conductor and the person who has ultimate responsibility for the ensemble's musical programming.

Artistic Administrator—the architect of the ensemble's season. This person works closely with the Music Director and the rest of the staff to ensure the financial and logistical viability of the Music Director's artistic goals for the season.

Director of Education—designs and oversees the ensemble's educational outreach activities into schools and the community and internal educational programming (children's concerts, etc.).

Director of Development—designs and oversees the ensemble's fundraising efforts; this person has deep relationships within the local business and philanthropic communities.

Director of Operations—oversees the smooth running of the physical performance and administrative spaces; can include a variety of other production-related duties.

Director of Finance—oversees the organization's accounting and budgeting.

Director of Marketing—designs and oversees the presentation of the season's programming to the public, working to entice them to attend concerts and support the orchestra in a variety of other ways.

Director of Patron Services—oversees the box office and takes care of the needs of the audience leading up to and during the concert.

Director of Public Relations—the orchestra's publicist; oversees the implementation of the media aspects of marketing the orchestra's activities.

Personnel Manager—oversees the orchestra players, determining and distributing scheduling details, handling pay and contract issues, and acting as the main conduit of information between the administration and the musicians.

Librarian—responsible for the purchase, rental, storage, condition, and distribution of the sheet music and scores from which the orchestra will perform.

Soloist/Recording Artist (any genre)

A musician who performs and/or records as a soloist or part of a band. This person often has an entire team around them to support the various facets of their career.

Personal Manager—the "quarterback" of an artist's team; the manager designs the overall strategy for the artist's career and oversees the implementation of that strategy, coordinating the efforts of all other members of the team. The personal manager, or "manager," is traditionally paid a percentage of the artist's earnings, typically 10–20%. In this changing music industry other models of compensation have emerged including "retainer-based management" and hybrid deals that combine the commission-based and retainer-based models.

Booking Agent—secures employment for the artist, primarily through live concerts, and executes contracts for that employment. Compensation for the agent is similar in structure and amount to that of the manager.

Tour Manager (road manager)—oversees daily logistics while on tour including press interviews, travel, lodging, arrival, setup, teardown,

venue catering, and instruments and gear. The tour manager is typically paid by the artist.

Attorney—provides legal advice and generates and negotiates contracts. The attorney is paid by the artist.

Publicist—works to secure media exposure for the artist's activities in print and online outlets, television, and radio. The publicist is paid either by the artist or the label. These days it is more common for the artist to bear this expense (and this would always be the case if the artist is independent).

Radio Promoter—distributes the artist's recordings to appropriate radio stations, whether terrestrial, satellite, or online, and continues to communicate with those stations, lobbying for the artist's music to receive airplay. Compensation for the promoter is handled in a manner similar to the publicist; they are paid either by the artist or the label.

Concert promoter—at larger clubs and venues this is the person who presents the concert and assumes responsibility for advertising the concert and selling tickets in return for a portion of the proceeds.

Performance Rights Organization (PRO)—a company that collects public performance royalties on behalf of composers/songwriters. Public performance royalties are the monies that are owed writers when their compositions are played in public places such as concert halls, bars and nightclubs, or on the radio. In the United States BMI, ASCAP, and SESAC are the three largest and most recognizable PROs.

Copyright Administrator—someone who helps a composer or songwriter to navigate the very complicated world of publishing by registering their copyrights and interacting with the writer's PRO (and that PRO's affiliates around the world) to collect any public performance royalties that are due to the writer. The copyright administrator is usually paid a percentage of the monies collected.

Publisher—an entity, whether owned by the composer/songwriter or a separate company, that holds 50% of the composition's copyright. The writer, as an individual, owns the other 50% (and this portion is divided if there are multiple writers). In certain situations, a publishing company will work actively on the writer's behalf to place the composition in places where it will earn royalties, such as on TV or in films or on recordings by other artists. As part owner of the copyright, the publisher earns a corresponding share of the royalty payments (if a writer is self-published, then they would receive this share of the royalty payment).

Studio Work

"Studio work" refers to recording projects that hire musicians to perform on a recording that will appear on someone else's album or product. These might be pop or country albums (or any other genre), recordings for

the background tracks used in performance with church bands and choirs, movies, or commercials.

Producer—the producer is to a recording what the conductor is to an orchestra. He or she applies their musical, technical, and sonic expertise to the process of recording a song or album in order to realize his and/or the artist's vision for the final product. In the commercial world (pop, country, etc.), the producer is also heavily involved in selecting songs and musicians for the recordings and for helping to determine the arrangements for the songs. They are often supported by production coordinators who handle producer agreements, union contracts, studio scheduling, cartage arrangements (the transportation of large instruments and equipment such as drums and amps to the studio), and any number of logistical details. Depending on the agreement, the producer is paid a flat fee and/or a percentage of the recording's royalties.

Contractor—the contractor hires musicians for recording sessions (and sometimes live performances) and is generally paid according to American Federation of Musicians (AFM) union scale for this task. For example, a contractor in a given city would be known by a producer to have connections to and knowledge of a number of musicians in that city. If the producer needed four trumpet players for a recording session, he would call the contractor to hire those musicians. Another example would be if a church wanted to have a string orchestra perform for a certain service, the church administrators or music directors might call a local contractor to hire those musicians. The contractor may or may not be a musician and may or may not be involved as a player in any given recording session or performance.

Recording Engineer—the person responsible for "turning the knobs" and capturing the recorded sounds in the studio. This person will be highly proficient at one or more mainstream recording and editing software systems (most likely ProTools) and will work closely with the producer during the recording session to record the music exactly as the musicians and producer want it to sound. After the recording session (the "tracking session"), the recording moves into post-production where a mixing engineer (possibly the same engineer, though not usually) will work with the recorded tracks of each of the instruments and vocals individually and in relation to each other to make it sound its best in the context of the entire recording. Finally, a mastering engineer "masters" the recording. They make sure that none of the tracks will cause distortion and that all of the songs on a recording are at the same volume level, and they optimize the recording for maximum audio quality on home playback systems. I think of mastering as the step that puts a bit of sparkle and polish on the sound of a recording and adds that subtle and intangible ingredient that distinguishes a professional recording from an amateur one.

Studio Manager—oversees the studio space including its scheduling, equipment, staff, physical infrastructure and security.

Record Labels

Record labels are companies that, historically speaking, have provided funding for the recording, distribution, and marketing of albums by the label's artist roster. Their role has changed in the digital era and continues to change. Though there is still no substitute for the power and economic scale of a large record label (which have been reduced in number by corporate mergers to just a handful), they are irrelevant to the overwhelmingly vast majority of recording artists. In this day and age many artists choose to go the "indie" route, paying for their own albums, doing their own marketing via social media and keeping the profits (whatever they may or may not be). There are a number of smaller labels that may be relevant to the indie-level artist in the classical, jazz, or singer-songwriter genres (I mention these genres not to exclude others, but because these are my areas of expertise). Labels at this level typically do not pay recording costs, but rather expect the artist to deliver a finished album that the label will then lease for a pre-determined number of years. I've found that these companies also expect that the artist will be able to deliver a well-developed fan base. In today's music industry it seems that these companies are rarely in the business of artist development.

CEO—responsible for the overall performance of the business, including oversight of all artistic and business decisions and strategies. This person acts as the quarterback for the company, determining strategy and working with the other team members, optimizing and utilizing their strengths, to achieve the company's overarching objectives.

Publicity Department—generates media exposure for the label's artists and works with the artist to determine styling and imaging—their "look." As part of the imaging oversight the publicity staff is present at photoshoots, video shoots, awards show red carpet walks, and so on.

Sales Department—handles the actual sale of songs and albums to retailers, including Target, Wal-Mart, Best Buy, and so on. It also develops strategy with regard to "positioning" and purchases this positioning. Examples of positioning include endcaps (in stores, these are the large displays on the ends of aisles), reduced price racks, posters, or banners in the store that advertise a certain release, and so on. CDs are purchased from the label for a wholesale price and can be returned if unsold (according to the specific terms of sale). Sales duties in the digital arena include the purchase of featured positioning at a given digital retailer, exclusive first listens and listening parties, and so on.

Marketing Department—creates a comprehensive plan (the marketing plan) that will drive sales of a given release. The plan encompasses the activities of the other departments—promotion, new media, publicity, sales; in this way the marketing department is the center of the wheel that is the record label, with spokes extending outward.

A&R Department—The Artists & Repertoire (A&R) Department selects artists for the label and works with the artists to select songs for their albums. They may select songs from outside songwriters or they may work with the artist/songwriter to select from his or her own catalog.

New Media Department—creates and executes marketing initiatives and products that exist and are deliverable online and via mobile devices, and as part of other new and emerging technologies. As you can imagine, this department has become much more central to the overall marketing plan in recent years.

Promotion Department—promotes singles to radio. Electronic and physical copies of a single are distributed to all of the radio stations in the format (country, rock, jazz, etc.). The promotion staff, often divided according to geographic region, follow up with their contacts at the stations and lobby for the label's songs to receive airplay. The airplay is measured and reported on the charts and the goal, of course, is to drive a song to the top of the charts and create a hit.

Creative Department—responsible for all of the company's graphics. These would include album covers and packaging, signage, online banners, stickers, and so on.

CHAPTER EIGHT

Repertoire
Programming the Concert of Life

When you consider a program for your recital, you strive to find a group of pieces that will challenge and excite you as well as be engaging and entertaining to the audience. Perhaps you want to challenge them a bit with a new work and then reassure them with something standard. Maybe it's your goal to represent a few different periods so you start with a Baroque piece, move into a Classical one, then Romantic, and so on. If you're a singer-songwriter, you might be trying to figure out where to place your two or three upbeat tunes between the many dark, brooding, introspective ones (joke!). In any case, you're stepping back and taking in the big picture. More accurately, you're creating the big picture. And you get to do that with your career, too.

As you pursue the various elements that will make up your career, take the time to consider these pursuits in the context of your life. And view your life as the marathon that it is, rather than as a sprint. This is a hard road we've chosen. Wonderful, but hard. There's euphoria in the chasing of this amazing dream, in getting to do the thing we love—getting to *play* for a living. But I promise you that there will be moments when the security and predictability of a nine to five job at a desk will seem attractive. Try to stay in touch with the long-term vision you have for your life, but also realize that vision may change and grow with you. For example, when I was in college I thought that I would love to be a touring musician with an ongoing road gig. Fast forward 15 years to a time when my life includes a wife and daughter and dog and house, and the job that would keep me away from all of that holds absolutely no appeal. But I love the excitement of creating that for other people as a manager and visiting it from time to time as a player. My original goal and vision has grown and evolved with me.

I got back in touch with this during the time that I was considering leaving my label job. I allowed my mental image of the immediate future to go blank. I tried to focus only on the things I wanted to do, what I

wanted my life to include. And I had conversations with people and musicians who I wanted to be a part of that in some way. That opened the door to the flow of ideas that were in keeping with this new outlook. They fit in this uncharted territory. It was very uncharacteristic for me, but is an exercise that I've repeated since then as I've approached various scenarios such as the creation of a new product or concert offering from a client. I guess you could call it "The Blank Slate Exercise." It's like the beginning of a recording session when the screen is blank and with each thing you play and each instrument you add the bars of graphically represented sound move across the screen. But even then you are not locked in. You can still add, delete, overdub, add effects, and make it into whatever you want. Approach your career in the same way. It was the rawest of passion that started you down this path. You were a kid probably, and you didn't start playing drums or piano or saxophone because you thought it would be the best choice for your retirement or because it would help you buy a new roof. You started because you loved the sound or you thought the instrument looked cool. Even if your parents made you play you wouldn't still be doing it if you didn't love it. So now is the time to persevere and be creative as you find ways to keep playing. . .*and* buy a new roof.

 Best of luck on your journey!

APPENDIX
ONE

TOUR ADVANCE CHECKLIST

ARTIST:	
CONCERT DATE:	
CITY:	
VENUE:	
VENUE ADDRESS:	
TIME ZONE:	
VENUE CONTACT (NAME/PHONE/EMAIL):	
DAY OF SHOW CONTACT (IF DIFFERENT):	
PARKING INFO:	
LOAD-IN TIME:	
SOUNDCHECK TIME:	
CONCERT TIME:	
NUMBER/LENGTH OF SET(S):	
FOOD PROVIDED:	
MERCH SALES TERMS:	
HOTEL/LODGING:	
NOTES:	

APPENDIX TWO

PERFORMANCE CONTRACT

The agreement below is made on _____, between _____(ARTIST) and _____(PRESENTER) for the services of ARTIST as described below.

Performance Date:	
Venue:	
Address:	
Website:	
Contact Name (info below signature):	
Performance Time(s):	
Number/length of set(s):	
Load-in Time:	
Soundcheck Time:	
Doors:	
Tech advance contact:	
Sound provided by:	
Concert Description:	
Billing:	
Due to ARTIST:	
Merchandise:	
Payment To Be Made As Follows:	
Cancellation:	

If PRESENTER cancels performance within 45 days of performance date, 50% of guaranteed fee will be due; if PRESENTER cancels performance within 7 days of performance date, 100% of guaranteed fee will be due.

Terms of any attached riders are part of this agreement.

If either party is prevented from performing contract obligations due to illness, acts of God (defined as fire flood, accident, riot, or order of any legal authority), or other legitimate conditions beyond the control of the parties to the agreement, neither party shall be liable for the balance of the agreement.

BY:	
Signature of PRESENTER	Signature of ARTIST/REPRESENTATIVE
Presenter:	Artist/Rep:
Address:	Address:
Work Phone:	Work Phone:
Cell:	Cell:
Email:	Email:

APPENDIX THREE

TOUR BUDGET

INCOME

DATE	CITY	VENUE	FEE
		TOTAL INCOME (A)	

EXPENSES

ITEM	AMOUNT	NOTES
Agent commission		
Manager commission		
Air/Train/Bus/Car rental		
Hotels		
Road Manager		
Artist/Bandleader		
Band member 1		
Band member 2		
Band member 3		
Band member 4		
Gas		
TOTAL EXPENSES (B)		

PROFIT/LOSS (A - B)

APPENDIX FOUR

10 Go-To Tools (in no particular order)

- www.bandzoogle.com (subscription based, DIY site builder)
- www.kayak.com (discount travel search engine that compares prices across all of the major travel sites for cars, hotels, airfare, etc.)
- www.hotelplanner.com (hotel search engine specializing in bulk rooms)
- www.tripadvisor.com (travel reviews—make sure your budget hotel isn't TOO sketchy)
- www.eventric.com (offers Master Tour, paid tour management software)
- Google Maps (I use this constantly for tour routing—making sure that two consecutive tour stops are within range of each other, etc.)
- Square (allows me to accept credit card payments in person via a swiper that plugs into my iPhone or remotely by entering the info manually—cost is a minimal 2.75% for swipes and 3.5% for manually entered transactions)
- Musical America (my monthly subscription is under $20 and allows me access to Musical America's large database of presenters including orchestras and performing arts centers)
- Viber (a free app that provides free international calling to other Viber users)
- Genius Scan (scan/send/save documents as PDF's with your phone)

APPENDIX
FIVE

Sample Promo Cover Letter and Onesheet

This letter and the onesheet that follows were sent to radio stations to promote trumpeter Scott Wilson's band Stark Raving and their "Kackle Jackle" release. (Cover Design: Meats Meier)

SOUNDARTIST SUPPORT

Brian Horner
P.O. Box 267
Old Hickory, TN 37138
(615) 364-7656
bhorner@soundartistsupport.com

Hello,

I've enclosed a copy of *Kackle Jackle*, the new recording from trumpeter Scott Wilson's band Stark Raving. Scott Wilson has established himself as one of the rising stars of jazz – both as a performer and as a pedagogue. Since earning two masters degrees from the University of North Texas and paying his dues on concert stages from Orlando to Osaka, Scott is in constant demand as a player, composer and educator. In addition to his dynamic live and recorded performances on trumpet, he is regarded as one of the world's foremost proponents of the electronic valve instrument (EVI).

Wilson has diverse international performance credits having shared the stage with jazz luminaries including Benny Green, Wayne Bergeron, Gordon Goodwin, Conrad Herwig, Wycliffe Gordon, Stevie Wonder, Jeff Coffin, Shelly Berg, Denis DeBlasio, Peter Erskine, Eric Marienthal, Bobby Shew, Slide Hampton, Terrell Stafford, Ron Blake, John Pizzarelli, Ed Shaughnessy, Alex Acuna, and others. He is joined in Stark Raving by a group of players that are not only Grammy-nominees and Downbeat Award-winners, but are renowned educators who have inspired thousands of young musicians.

Kackle Jackle features six Scott Wilson originals and three carefully chosen covers (from John Coltrane, Hank Mobley, and Joe Henderson) and has broad appeal across multiple formats. A transcription book has been released as well that features transcriptions of the trumpet, EVI, and trombone solos.

I've also enclosed a onesheet that gives a bit more information about the project and provides a track listing with focus tracks.

Please feel free to contact me with any questions you may have or to schedule an interview with Scott or any of the members of the band. We're happy to provide complimentary copies for you to use as giveaways if you'd be interested. Thanks for your time and consideration.

Sincerely,

Brian Horner

76 Appendix Five

TRACK LISTING:
1. Kackle Jackle (5:22) * FOCUS TRACK *
2. View For Kings (4:06)
3. Voodoo Dance (4:09)
4. Kiss That Told Me (5:30)
5. Green Bird (3:28) * FOCUS TRACK *
6. Lonnie's Lament (3:46)
7. Home At Last (5:37)
8. Recorda Me (3:49) * FOCUS TRACK *
9. Needing You (8:07)

PRAISE FOR SCOTT WILSON AND *KACKLE JACKLE*:

"While possibly best known for his decades of jazz education innovations, on Kackle Jackle Scott Wilson displays his considerable chops and technique as a brassman, improvisor, and composer. Wilson is equally comfortable on the EVI, blazing effortlessly over changes and maximizing the flexibility of the instrument. Whether on his own clever compositions or on standards of the genre, Wilson's playing is some of the best in modern jazz!"
Caleb Chapman – Former International Jazz Educator of the Year

"Scott Wilson is a tremendous trumpet player! His ability to cross styles while still retaining his own personal style is something special. He brings the fire on every tune and weaves his personality into each solo. Beautiful stuff!"
Jeff Coffin – Dave Matthews Band (and formerly Bela Fleck & the Flecktones)

"Having spent the better part of the past 30 years attempting to master the Electronic Valve Instrument, I am happy to say that Scott Wilson remains one of my favorite EVI players. And his EVI performances on this CD are especially uplifting."
Mike Metheny – Trumpeter and EVI player

APPENDIX
SIX

Sample Marketing Materials

This is a poster used by singer-songwriter Erin Thomas to promote live shows—she mails several of these to venues a few weeks before a show. The venue can fill in the details and post them locally. The single incredible quote and photo say it all. (Photo Credit: Wendy House Photography)

77

78 Appendix Six

This postcard was mailed to orchestras (using a mailing list purchased from Musical America) to advertise a new concert offering from Broadway star Mike Eldred. We used quotes, two compelling images, and a brief overview of his impressive resume of symphony pops performances. (Photo Credit: D. Pierce Studio)

Appendix Six **79**

SOUND ARTIST SUPPORT

P.O. Box 267
Old Hickory, TN 37138

Mike Eldred
*"American Landscapes &
The Very Best of John Denver"*

CONTACT:
Brian Horner
Sound Artist Support
(615) 364-7656
bhorner@soundartistsupport.com

- 2011-12 Season included appearances with the symphonies of Houston, Detroit, Nashville and San Diego

- Favorite star and host of holiday pops concerts with the Toronto, Baltimore, Long Beach, and Indianapolis symphonies

- Upcoming performances include concerts with the symphonies of Portland (ME), San Diego, and Toronto

80 Appendix Six

 Similar in purpose to the postcard, this folding self-mailer (held closed by a small, round sticker) was mailed to orchestras to advertise John Mock's multimedia pops concert. (Photo Credit: John Mock)

travel from the concert hall to the coasts of the Atlantic...

From The Shoreline - A Coastal Journey

- A Maritime Pops Concert Experience with composer, photographer & multi-instrumentalist

John Mock

"Wonderfully evocative, beautifully written and performed. Audience reaction was very positive. The orchestra also really enjoyed the concert, not least because the orchestrations were superb and the materials exemplary."
- Robin Fountain,
Music Director Southwest Michigan Symphony

"John Mock is a composer who knows how to feature the orchestra while fusing classical, folk and popular styles into powerful new works."
- Paul Gambill,
Music Director Nashville Chamber Orchestra

John Mock is an artist and the sea and its coasts are his muse. From New England to Chincoteague to Ireland, the Atlantic's beautiful coastline and quaint villages, its wooden boats and whitewashed lighthouses, continue to inspire and inform John's art. He captures in music and in photographs the heritage of the sea and integrates all of this into an elegant multi-media concert presentation unlike any other – "From The Shoreline – A Coastal Journey".

The concert features John's original folk-classical music inspired by coastal scenes that he has also photographed. He performs his instrumental works on guitar, mandolin, concertina and tin whistle with his exquisite photography projected onto a screen behind him. His casual narration and story-telling tie it all together. With beautiful melodies that evoke the romance and majesty of the Atlantic coasts from New England to Ireland, this show provides a unique, audience-pleasing, and economical pops offering. Instrumentation is flexible and can range from a solo performance in a house concert or fundraiser setting, to a quartet, string orchestra, or full orchestra concert.

A native of Connecticut's eastern shore, John's work has taken him around the world. Widely sought after as a composer, arranger and multi-instrumentalist, he has worked with such notable artists as the Dixie Chicks, James Taylor, Nanci Griffith, Maura O'Connell, Sylvia, Kathy Mattea and Mark O'Connor. His orchestral arrangements have been performed by orchestras throughout America and abroad, including the London Symphony, the National Symphony and the symphonies of Atlanta and Nashville.

John's credits as composer and featured artist include performances with, among others, the Nashville Chamber Orchestra, the National Orchestra of Ireland, and the Southwest Michigan Symphony Orchestra, as well as solo performances throughout the country.

"John Mock's paring of music with his photography was truly a delight. He has captured the essence of the sea, and is able to portray that through his work."
- Caroline C. Leyden, The Mariners' Museum, Newport News, VA

For booking inquiries, please contact
Brian Horner at Sound Artist Support
(615) 364-7656 – bhorner@soundartistsupport.com.

For audio samples, visit
John online at **johnmock.com**

Appendix Six **81**

Sound Artist Support
P.O. Box 267
Old Hickory, TN 37138

travel from the concert hall to the coasts of the Atlantic…

From The Shoreline
*- A Maritime Pops Concert Experience with
composer, photographer & multi-instrumentalist*

John Mock

"John Mock's pairing of his music with his
photography was truly a delight. He has captured
the essence of the sea, and is able to portray that through his work."

- Caroline C. Leyden, Manager of Indoor Special Events
The Mariners' Museum, Newport News, VA

82 Appendix Six

 There are a couple of things to notice in this brochure from John Mock, which was sent to gift shops to advertise his CDs and photographic prints. John purchased a large quantity of wooden boats that were the perfect size to hold 10 of his maritime-themed CDs and offered them to stores for free with any CD order of 10 or more. I was the one on the phone with stores to follow up on this mailing and it was a very effective incentive. He has used quotes from others and lots of photographic examples of his products, and has taken great care to design a professional and appealing layout. (Photo Credit: John Mock)

From The Shoreline

Maritime Music & Fine Art Photography from composer, photographer & multi-instrumentalist

John Mock

From New England to Chincoteague to Ireland, the Atlantic's beautiful coastline and quaint villages, its wooden boats and white-washed lighthouses, continue to inspire and inform John's art. He captures in music and photographs the heritage of the sea.

Pricing & Information

Audio CD:

The Day At Sea

Wholesale price $7.00
Purchase 10 CDs or more and receive a hand-varnished wooden boat CD displayer for free see inside for CD displayer photo

Photographic Prints:

For all available prints, please visit johnmock.com

4x6 Standard print centered within a white 8x10 mat
- Wholesale price $8.00

6x9 Giclee Gallery print centered within a white 9x12 mat
- Wholesale price $25.00

8x12 Giclee Gallery print centered within a white 14x18 mat
- Wholesale price $40.00

For ordering & information please contact:
Brian Horner • Sound Artist Support • (615) 364-7656
bhorner@soundartistsupport.com

Appendix Six **83**

Photographic Prints

Castle Hill Lighthouse, RI

Chowder House, ME

Pemaquid Moon, ME

Brandt Point Sunset, MA

Stonehaven, Scotland

Chatham Windmill, MA

O'Brien's Castle, Ireland

The Lobster Pot, MA

For all available prints, please visit johnmock.com

Audio CD

The Day At Sea

"... this music has the feel of clapboard and canvas, rustic inns and whitewashed lighthouses. The salt air breathes inside it."
— Amazon.com review

"... stunning and soul-stirring. John Mock has absorbed the maritime geography, internalized it, and fashioned it into a different kind of coastline washed in melody and harmony."
— Craig Bickhardt

"This is a wonderful mental vacation to New England. It conjures up images and impressions of the sea and its shore."
— CD Baby.com review

Purchase 10 CDs or more and receive a hand-varnished wooden boat CD displayer for free.